2010

D0349641

To MARTHA

Marty Brown

Declarer Play
the
Bergen Way

By Marty Bergen

Bergen Books

Bergen Books
9 River Chase Terrace
Palm Beach Gardens, FL 33418-6817

First Printing: July 2004
Second Printing: April 2007

Library of Congress Control Number: 2004094696

ISBN: 0-9744714-2-9

Bridge Books by Marty Bergen

Bergen for the Defense

More Declarer Play the Bergen Way

Bergen's Best Bridge Tips

Bergen's Best Bridge Quizzes, Vol. 1

To Open, or Not to Open

Better Rebidding with Bergen

Hand Evaluation: Points, Schmoints!

Understanding 1NT Forcing

Marty Sez

Marty Sez...Volume 2

Marty Sez...Volume 3

POINTS SCHMOINTS!

More POINTS SCHMOINTS!

Introduction to Negative Doubles

Negative Doubles

Better Bidding with Bergen, Volume I

Better Bidding with Bergen, Volume II

Thanks To:

Layout, cover design, and editing by
Hammond Graphics.

My very special thanks to: Cheryl Angel, Cheryl Bergen, Trish and John L. Block, Ollie Burno, Caitlin, Nancy Deal, Pete Filandro, Jim Garnher, Terry Gerber, Lynn and Steve Gerhard, Marilyn and Malcolm Jones, Steve Jones, Doris Katz, Danny Kleinman, Alex Martelli, Harriet and David Morris, Phyllis Nicholson, Helene Pittler, David Pollard, Sally and Dave Porter, Mark Raphaelson, Jesse Reisman, Carl Ritner, Mark Rosenholz, John Rudy, Maggie Sparrow, Tom Spector, Bobby Stinebaugh, and Bob Varty.

The Official Encyclopedia of Bridge – Fifth Edition
by Henry and Dorthy Francis, Alan Truscott

FYI

You are always South.
South is always the declarer.

N-S (North-South) always refers to your side.
E-W (East-West) always refers to the defenders.

Every bidding diagram begins with West.

West	North	East	South
—	—	—	2♡
All Pass			

The dashes are place holders, and in the example above, show that the auction did not begin with West, North, or East. The dealer was South.

The "—" does not indicate a "Pass."

CONTENTS

CONTENTS

More Good Stuff

From the Author

Welcome to my first (but not last) book on declarer play. I've tried to make this book as helpful and instructive as possible, so every chapter is based on a practical topic. Of course, as with all my books, I hope that *Declarer Play the Bergen Way* also proves to be entertaining.

Before reading the deals and tips that follow, consider the following. Even if you usually play matchpoint duplicate, in this book you should concentrate on making your contract. Until the contract is assured, don't even think about overtricks. By the way, on most deals, even when you're playing matchpoints, you won't go wrong with this approach.

Because no two players have the exact same preferences, I varied the format a little from deal to deal. Some are presented in "test your play" form, so you have an opportunity to find the solution on your own. I included questions on these to help you focus on the most relevant issues. Other deals are presented as they were actually played.

Of course, you're always welcome to test yourself by covering up the E-W hands, or to avoid all tests by reading on without answering the questions.

As for the bidding, on most deals, the auction is included. If no auction is given, it means that the N–S bidding was straightforward, and E-W passed throughout.

I recommend that you check out the back of the book. Here you will find:

I. Bergenisms: Pages 181-196
These "tip highlights" provide many practical, carefully-worded statements that can prove invaluable to the reader in countless situations.

 A. Declarer Play
 B. Bidding
 C. Defense and Opening Leads

Although this book focuses on declarer play, on some deals, the discussion of the bidding and/or defense provides helpful hints that are worth emphasizing.

II. Reader-Friendly Glossary Plus: Pages 197-209
Practical declarer-related terms *and advice* will do a lot more than simply allow you to "talk the talk." This section will definitely improve your knowledge and technique, as well as clarify uncertainties and popular misconceptions. Most terms are discussed in this book, but I also included a few others that are important, or in a few cases, amusing.

 Best wishes,
 Marty Bergen June 2004

Relevant Bidding & Defense in This Book

Opening bids based on the Rule of 20.
Five-card majors.

1NT opening bid = 15-17 HCP.
2NT opening bid = 20-21 HCP.
Jacoby Transfers

2♣ opening bid is strong, artificial, and forcing.
Weak two-bids in diamonds, hearts, and spades.

Standard Blackwood (not RKC).

Responding to Partner's Opening Bid:

Natural raises of minors (no Inverted Minors).

1NT response to a major:
Whether you are or are not playing 1NT Forcing
is not relevant in this book.

A response in a new suit at the two level:
Whether you are or are not playing 2/1 Game-Forcing
is not relevant in this book.

Defense:
Opening Leads: A from AK, and 4th best.

Signals: Standard

Chapter 1

Getting Off
on the Right Foot

Thinking After Seeing Dummy

Try not to think about:

- What other contract would you prefer to be in?

- Any bad bids that your partner may have made.

- Any of your bids that worked out badly (despite being very reasonable).

Try to memorize:

- The opening lead.

- Dummy's distribution and honor cards.

Make sure that you:

- Avoid playing quickly.

- Count winners and/or losers.

- Consider the opening lead.
 On your auction, is it the expected lead?

- Think about entries to both hands.
 If you have a choice of where to win the
 first trick, think some more about entries.

- Don't automatically win the opening lead,
 just because you are able to do so.

Most importantly: Do not start playing without a plan. Entire books have been written in which the fate of each deal depends on what declarer did at the first trick! Even an imperfect plan is better than none.

Where, Oh Where Should I Be?

When you have a choice of where to win a trick, think carefully about where you'll need to be **later on.**

	North	
Contract: 3NT	♠ A 9 7 5 4	
Lead: ♡J	♡ K 7 4	
	◇ A K 10	
	♣ A 4	

West	*East*
♠ K 10	♠ Q J 8 3
♡ J 10 9 5 2	♡ Q 8 6
◇ J 9 7 5	◇ Q 2
♣ 7 5	♣ K 8 6 3

South
♠ 6 2
♡ A 3
◇ 8 6 4 3
♣ Q J 10 9 2

West	*North*	*East*	*South*
Pass	1♠	Pass	1NT
Pass	3NT	All Pass	

What would you do at trick one?
You have three choices:

A. Win the ♡A.
B. Win the ♡K.
C. Duck in both hands.

I suggest making your decision before reading on.

You have six sure winners in aces and kings:
one spade, two hearts, two diamonds and one club.
You need three extra tricks, and it would be nice
if you could get all three from the same suit.

One suit stands out – clubs. No other suit offers any
hope of developing three additional tricks. The only
significant club you're missing is the ♣K, so you
should be able to win four tricks while losing just one.

Do not make the mistake of winning the ♡A and
leading the ♣Q. Also, don't duck the opening lead.
A second heart lead will prematurely force out your
precious ♡A entry to the long clubs.

As long as you can get to your hand *after* the clubs are
established, you're sure to win three extra club tricks.
Therefore, **you must save the ♡A for later.**

Instead, you must win the opening heart lead with
dummy's king and play the ♣A, and then continue
with the ♣4.

It makes no difference who has the ♣K. E-W can win
the ♣K whenever they want, but you're sitting pretty
with your club winners and carefully-preserved ♡A.

Remember: When you are setting up a suit,
"Use up the honor(s) from the short side first."
This guideline has very few exceptions.

Bridge Mathematics

"Fascinating in so many ways, there is one aspect
of bridge that bores me intensely – the pursuit of
hair-splitting percentages and abstract probabilities."
<div align="right">Victor Mollo</div>

Many players believe that bridge is a mathematical
game – but that is not true. Yes, basic arithmetic is
very relevant in bridge, just as it is in life. However,
the key to bridge is logic and reasoning.

If a player passes his partner's opening bid of one in
a suit, you are confident that he has fewer than six
points. If that player shows up with an ace during the
play, you will be confident that any missing queens,
kings, or aces are held by his partner. Simple enough.

You do need to know some basic percentages –
fortunately, nothing could be simpler. When you lead
low toward the AQ, the king will be located favorably
half the time. A simple finesse, then, has a 50%
chance of success. Of course, you already knew this.

Basic percentages also play a significant role in
understanding the likely distribution of the defenders'
cards. Whether or not you are a whiz with numbers,
don't fret – this will prove to be an easy topic to learn.

Here are the important principles:

1. **When you are missing an odd number of cards, expect them to divide as evenly as possible**.

If you're N-S in an 8-card fit, E-W have 5 cards. You can't expect them to divide 2½-2½; therefore expect 3-2. The same holds true when your side has 10 cards. Their 3 cards are probably divided 2-1.

2. **When you are missing an even number of cards, do not expect them to divide perfectly**.

If your side has a total of 7 cards, the other side has 6, and those 6 will divide perfectly (3-3) only slightly more than 1/3 of the time. It isn't likely that the suit will split 5-1; so expect the suit to split 4-2.

You are now armed with all the bridge mathematics you need. But, for those who want more specifics:

When you are missing 5 cards:

A 3-2 split will occur 67.83% of the time.
A 4-1 split will occur 28.26% of the time.
A 5-0 split will occur 3.91% of the time.

When you are missing 6 cards:

A 3-3 split will occur 35.53% of the time.
A 4-2 split will occur 48.45% of the time.
A 5-1 split will occur 14.53 % of the time.
A 6-0 split will occur 1.49% of the time.

This Dummy is No Dummy

When dummy tables his cards, he should hold the suit led and put it down last.

Why should he do that? It forces declarer to look over the other three suits before playing to the first trick. There's no question that *many* makable contracts are lost when declarer plays too quickly at trick one.

Most players are so excited to become declarer that, as soon as dummy is tabled, they're off and running. Even if they are one of the five best players in the world, they can't play effectively at *that* speed.

By the way: There are lots of other little things you can do to help partner when tabling dummy.

- Alternate colors – don't put clubs next to spades, or diamonds next to hearts.

- Each suit should be arranged from highest to lowest. The higher cards must be closer to you.

- Make sure to space the cards neatly so that declarer can easily see how many you have in each suit.

- In a notrump contract, keep the suit(s) bid by your side on your left. This reduces the chance of a confused declarer thinking that one of those suits became the trump suit.

Chapter 2

Count Your Way to the Top

ABCs of Counting

"Counting to a bridge player is similar to an actor learning his lines – it does not guarantee success, but he cannot succeed without it." George S. Kaufman

Question: What must you count? Here is a possible list. Please don't be overwhelmed by it. Don't worry if you are unable to do everything listed – I'm only trying to make some suggestions. If, after reading this chapter, you *are* able to do a better job of counting, I'm delighted, and hope you are as well.

Answer: Based on the bidding and early play, declarer should try to figure out (and keep track of) as many of the following as possible.

- Your winners and/or losers;
- The defenders' HCP;
- Trumps;
- What happens in your key side suit;
- The opening lead.

You always know what declarer and dummy have. So, once you know what one defender has in a suit, you can figure out what his partner has. Similarly, when you know a defender's length in three suits, by subtracting from 13, his length in the 4th suit is easy.

Marty Sez: He who knows three, knows all four.

Memorizing the Opening Lead

In order to count well, you need to remember some of the defenders' cards. No one can memorize every card that the opponents play; however, declarer must remember the card that was led. While knowing the exact card won't solve all your problems, sometimes that knowledge can prove to be invaluable.

One of the most telltale cards is an opening lead of a deuce in a notrump contract. This tells declarer that his LHO had exactly 4 cards in the suit that was led. On some deals, this information also allows declarer to figure out something about another suit.

For example:

	North
Contract: 3NT	♠ A Q
Lead: ♠2	♡ 7 5 4 3
	◊ Q 10 4 3
	♣ A J 3

South
♠ J 3
♡ K J 9
◊ A K J 6
♣ K 9 6 2

West	*North*	*East*	*South*
—	—	—	1NT
Pass	3NT	All Pass	

With extra high cards and a very weak major, North didn't bother with Stayman (I agree). Whether or not you agree, on this hand, all roads lead to 3NT.

You finesse the ♠Q at trick one, but East wins the king and returns a spade. It doesn't look good. You no longer have a spade stopper and you have only 7 winners: 2 clubs, 4 diamonds, and 1 spade.

In addition to already winning the ♠K, the defenders are poised to win the ♡A and three spade tricks. Therefore, unless the defenders discard very poorly, your only hope is to win two additional tricks in clubs.

However, it costs nothing to give the enemy a chance to throw away some clubs. For now, run diamonds and watch the discards.

You cash the ◇A and lead the ◇6 to the 10. East and West both follow. You then cash the ◇Q and West discards the ♠10. When you lead the ◇4 to the king, both defenders discard hearts. Too bad, no one threw a club. Regardless, it's time to finesse clubs.

You lead the ♣2, West plays the 5 and you finesse the jack. East follows with the ♣4. Excellent! You then cash dummy's ♣A. East plays the ♣7 and West drops the queen. Very interesting!

You lead dummy's ♣3 and East follows with the 8. Would you finesse the nine, or go up with the king?

Did you play the ♣9 to take the marked finesse
against East's ♣10? Most players would do the same.
Unfortunately, as you can see on the next page,
your 9 loses to West's 10 and E-W will run spades
and you'll be down two!

When you cashed the ♣A, West defended well by
dropping the queen. After you finessed the ♣J, he
was marked with the ♣Q. A fundamental principle
of defense is: **when declarer knows you have a
certain card, as long as you can afford it, play that
card ASAP, rather than letting him see any of your
other cards.**

West fooled you with his intelligent falsecard.
You have my sympathy. However...

If you had stopped to count, you could have had the
last laugh. After the ♠2 opening lead, you knew that
West started with 4 spades. You then discovered that
he had 2 diamonds. **Therefore, he must have
started with a total of 7 cards in clubs and hearts.**

After West dropped the ♣Q, your instincts told you
that West started with 2 clubs. However...

If he had only 2 clubs, he would have started with
5 hearts. No way! Regardless of West's bridge level,
after an auction of 1NT – 3NT, no player would lead
a lousy 4-card major when he had a 5-card major.

Because West could not have started with 5 hearts, **he must have a third club.** Next time, you will congratulate West for his excellent technique, but you'll go up with the ♣K and score up 3NT.

Here is the entire deal:

North

Contract: 3NT ♠ A Q
Lead: ♠2 ♡ 7 5 4 3
◇ Q 10 4 3
♣ A J 3

West	*East*
♠ 10 8 7 2	♠ K 9 6 5 4
♡ 10 8 6 2	♡ A Q
◇ 5 2	◇ 9 8 7
♣ Q 10 5	♣ 8 7 4

South
♠ J 3
♡ K J 9
◇ A K J 6
♣ K 9 6 2

West	*North*	*East*	*South*
—	—	—	1NT
Pass	3NT	All Pass	

When Drawing Trumps, Count on the Opponents

Counting trumps should be a straightforward process.
The following deal illustrates the simple yet effective
technique which I recommend to players of all levels.

	North
Contract: 4♠	♠ 6 5
Lead: ♡Q	♡ K 7 6 5 2
	◇ 10 3
	♣ K J 4 3

West	East
♠ J 9 4 3	♠ 8
♡ Q J 10 9	♡ A 4 3
◇ Q J 2	◇ 9 8 7 6 4
♣ 7 5	♣ A 10 6 2

South
♠ A K Q 10 7 2
♡ 8
◇ A K 5
♣ Q 9 8

West	North	East	South
—	Pass	Pass	1♠
Pass	1NT	Pass	4♠
All Pass			

With only two sure losers, prospects are good.
The ♡Q is led, and it is time to think about the
defenders' trumps. You have 6 spades and dummy
has 2, a total of 8. Therefore, the defenders started
with exactly 5 spades.

After winning the ♡Q, West leads a second heart,
which you ruff. **You don't need to keep track of that
trump**. The defenders began the hand with 5 spades,
and they still have all of those.

Of course, you're not ready to draw trumps. First,
you must ruff your ♢5 while dummy still has trumps.
You cash the ♢AK and ruff a diamond with the ♠5.
You don't need to count that trump either.
The defenders' five spades are still intact.

Now you're ready to draw trumps. Lead dummy's ♠6
to your ace. Both defenders follow – 2 down, 3 to go.
You cash the ♠K, and East discards a diamond.
You know that West still has 2 trumps, since only
3 of the enemy's 5 spades have been accounted for.

Cash the ♠Q, pulling one more trump from West.
Now leave him with his trump winner and play clubs.
Your only losers are 1 heart, 1 spade, and the ♣A.

By the way: This same "keep track of the defenders'
cards, not your own" technique is also useful when
counting other suits.

Sherlock Holmes is On the Job

A good declarer has a lot in common with a good detective. First, the detective works hard to uncover all the evidence. Then he must sift through what is in front of him and evaluate what he has learned. Only then can he possibly know "whodunit."

An experienced bridge player is always looking for clues. Because both sides are communicating through their bidding and play, information is always available. Paying attention to what goes on during the bidding and play of a bridge hand is the trademark of a good sleuth. Here's your chance to play Sherlock Holmes.

	North
Contract: 4♠	♠ 6
Lead: ♡K	♡ 8 7 4 2
	◇ J 8 5
	♣ 7 6 5 4 2
	South
	♠ A K Q J 9 2
	♡ A 5
	◇ K Q 9 6
	♣ 3

West	*North*	*East*	*South*
1♣	Pass	2♣	4♠
All Pass			

Because all you need to make a game is a little bit
of help in diamonds, you see no reason to delay
the issue, and correctly jump to 4♠ at your first turn.

You win the heart lead and begin drawing trumps.
Both defenders follow to the first two rounds.
West also follows to the third and fourth round,
while East discards the 9 and jack of clubs.

You then begin to develop your diamond suit.
West captures the ◇K with his ace and continues
with the ♡Q J as East follows suit to both.
You ruff the third heart with your next-to-last trump.

Your key suit is diamonds, but you can afford to stall.
If a defender is foolish enough to help you by leading
a diamond, you exit with a club. East wins the ♣Q,
and leads the ace – that's no help. You ruff with your
last trump. Oh well, back to the drawing board.

Ready or not, the time has come for all good men
(and women) to find out what their diamonds really
are worth. When you lead to dummy's ◇J, both West
and East follow suit. You lead a diamond to your
Q 9 and East follows with the 7.

To finesse or not to finesse, that is the question. Is it
just a guess? Which diamond do you play – and why?

Let's examine the clues. N-S started with 6 clubs and 6 hearts, so E-W started with 7 cards in each of those suits. For his raise to 2♣, East must have had 4-card support, but denied having a 4-card major. **Therefore, West started with 3 clubs and 4 hearts and East had 4 clubs and 3 hearts.**

When you drew trumps, you discovered that West had 4 spades and East had 2. You now know it all: **W:** 3 clubs + 4 hearts + 4 spades = 11 "nondiamonds." **E:** 4 clubs + 3 hearts + 2 spades = 9 "nondiamonds." So, West started with 2 diamonds, while East had 4. "Watson, the case is solved." East *must* have the ◇10. Finesse the ◇9 and score up your game.

Here is the entire deal:

	North	
Contract: 4♠	♠ 6	
Lead: ♡K	♡ 8 7 4 2	
	◇ J 8 5	
	♣ 7 6 5 4 2	
West		*East*
♠ 10 7 5 4		♠ 8 3
♡ K Q J 9		♡ 10 6 3
◇ A 3		◇ 10 7 4 2
♣ K 10 8		♣ A Q J 9
	South	
	♠ A K Q J 9 2	
	♡ A 5	
	◇ K Q 9 6	
	♣ 3	

Chapter 3

Finesses:
Not Always Obvious

Getting There is Half the Fun

Contract: 3NT
Lead: ♠J

North
♠ A
♡ 7 6 4
♢ Q J 10 8 6 5 4
♣ A 10

South (You)
♠ Q 6 5 4 3
♡ K J 9
♢ A
♣ K Q 7 2

West	North	East	South
—	1♢	Pass	1♠
Pass	2♢	Pass	3NT
All Pass			

With a strong hand and weak spades, you didn't look for a 5-3 spade fit, but instead jumped to 3NT.

You would have liked to develop diamonds, but West's spade lead knocked out a crucial entry to dummy. Unfortunately, without the diamonds, you have no chance to make nine tricks. You desperately need to find an entry to the board in addition to the ♣A.

Question 1: Is there any hope of a second entry?

Question 2: After you lead a diamond to your ace at trick two, what is your plan?

Question 1: Is there any hope of a second entry?

Answer: Yes, dummy's ♣10 provides a 50% chance of giving you the additional entry that you *must have*.

Question 2: After you lead a diamond to your ace at trick two, what is your plan?

Answer: Lead a club, finesse dummy's ♣10 and say your favorite prayer. If West has the ♣J, dummy's ♣10 will provide the crucial second entry to the board. You'll then drive out the ◇K and await developments.

Of course, even if the club finesse wins, you're not out of the woods yet. Although the ♣A remains as an entry to dummy's diamonds, you have no idea what will happen in the majors. Depending on the location of the defenders' honors in diamonds, hearts, and spades, you could end up with as many as ten tricks, or as few as seven or eight.

Postscript:
On the actual hand, good news was followed by more good news.

First: and foremost, the ♣10 won. Yes!!

Second: When you then led dummy's ◇Q, you were pleased when West won the ◇K. You certainly were not looking forward to East's leading through your fragile major suits.

Third: Because East would never get the lead, the contract was not in jeopardy. What happened next? West defended well by exiting with a club. When you eventually came off dummy with a heart, West took the last three tricks with the ♡AQ and the ♠K. But with 6 diamond tricks, 2 clubs and 1 spade, you were delighted to score up your game.

Here is the entire deal:

North
♠ A
♡ 7 6 4
◇ Q J 10 8 6 5 4
♣ A 10

Contract: 3NT
Lead: ♠J

West
♠ K J 10 9 7
♡ A Q
◇ K 3 2
♣ J 6 4

East
♠ 8 2
♡ 10 8 5 3 2
◇ 9 7
♣ 9 8 5 3

South
♠ Q 6 5 4 3
♡ K J 9
◇ A
♣ K Q 7 2

West	North	East	South
—	1◇	Pass	1♠
Pass	2◇	Pass	3NT
All Pass			

The ♣8 Saves Your Bacon

	North
Contract: 3NT	♠ 7 6 3
Lead: ♠Q	♡ 10 4 2
	◇ K 6 4 2
	♣ A 9 5

West	*East*
♠ Q J 10 5	♠ 9 8 4 2
♡ K Q 9	♡ J 8 6 3
◇ J 10 8 7	◇ 9
♣ K 2	♣ J 10 7 6

	South
	♠ A K
	♡ A 7 5
	◇ A Q 5 3
	♣ Q 8 4 3

West	*North*	*East*	*South*
1◇	Pass	Pass	**2NT**
Pass	3NT	All Pass	

**In the balancing seat, South's jump to 2NT
should not be treated as the Unusual Notrump.**
It should show a strong hand of 19-21 HCP,
inviting partner to raise to game if he has some help.

There is nothing wrong with the auction; after all, you brushed aside West's opening bid and reached 3NT with 26 HCP and all suits stopped. Unfortunatly, your chances of taking nine tricks are not good.

You have 7 obvious winners: 3 diamonds, 2 spades, 1 heart, and 1 club. There is no hope of winning any extra tricks in the major suits, so you must hope to make something out of the minors.

After winning the spade lead with the king, you lead a diamond to the king, and a diamond to your ace. East discards a spade on the second round, confirming that West started with four diamonds. So much for that suit. At this point, your only hope is to try to develop two additional tricks in clubs.

However, the normal play of leading a club to the ace and a club towards your queen is hopeless, because West needs the ♣K to justify his opening bid.

Instead, your best chance is to hope that West started with a doubleton or singleton ♣K. Lead low from your hand and when West plays low, insert the nine, allowing East to win the 10. When you regain the lead, cash dummy's ace, capturing West's king. It is now easy to lead dummy's ♣5 and finesse through East's remaining ♣J7 to your ♣Q8.

For those interested in bridge lingo, this is referred to as an *intra-finesse*.

Another Not-So-Obvious Finesse

North is on lead.

North

Q 7 4

South (You)

A 10 5

You need to win two tricks in this suit to fulfill your contract. You should not lead the queen – you cannot afford to sacrifice that card. A useful rule of thumb for declarer is: **lead an honor for a finesse only when you are eager to see it covered.** If your reaction after the honor is covered is, "*darn*," you should not have led the honor in the first place.

It would also be wrong to lead the 4 to the ace and lead towards the queen. That play would succeed only if West was dealt the king – a 50-50 chance.

Instead, cross to your hand in another suit and lead your five. If West has the king, you are home free. If he takes it, the queen is a winner. If West ducks, you'll play the queen and win the trick.

However, if West plays low and dummy's queen is captured by East's king, you still have a 50-50 chance. Enter the North hand in another suit and lead dummy's 4 and finesse your 10. As long as East holds the jack, the second trick is in the bag.

A Very Deep Finesse

"One advantage of bad bidding is that you get practice at playing atrocious contracts."

Alfred Sheinwold

Everyone knows how to finesse with xx opposite AQ. But that is just the tip of the iceberg. It is possible to finesse against virtually any card.

I'm sure that you bid much too well to arrive at a contract requiring the desperate measures needed on the following deal. But, if the same cannot be said of your partner, I'd like to present – the *ultimate finesse*:

Contract: 6NT
Lead: ♡10

North
♠ 10 9 2
♡ K Q J
♢ K Q J
♣ A 6 5 2

South
♠ A K 6 4
♡ A 7 6 3
♢ A 7 6
♣ 10 4

West	*North*	*East*	*South*
—	—	Pass	1NT
Pass	6NT	All Pass	

West leads the ♡10 against the overly-ambitious 6NT
contract. An invitational 4NT (not Blackwood) would
have been a better bid with the flat North hand.
Be that as it may, you are now in a slam with only
10 winners: 2 spades, 4 hearts, 3 diamonds and 1 club.
Therefore, your only hope of making 6NT is to win
2 additional spade tricks!

Believe it or not, there *is* a chance. You need the E-W
spades to be divided exactly like this:

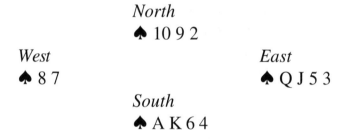

North
♠ 10 9 2

West
♠ 8 7

East
♠ Q J 5 3

South
♠ A K 6 4

You win the heart in dummy and lead the ♠10.
Suppose East covers with the jack (it would not
help him to play low). You win with the king,
as West drops the seven. Cross to dummy with a
heart and lead the ♠9. East covers with the queen
(again, no difference if he ducks). You capture this
with your ace, felling West's eight.

You have succeeded in setting up your six as a third
spade winner, but you still require an additional trick.

Here is the remaining layout:

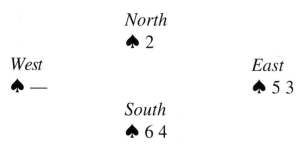

North
♠ 2

West
♠ —

East
♠ 5 3

South
♠ 6 4

Cross back to dummy in another suit and lead the ♠2.
When East plays the 3, finesse your 4. This represents
a successful finesse against the 5. You now cash your
6 and chalk up your slam. What an amazing game!

Here is the entire deal:

North
♠ 10 9 2
♡ K Q J
♢ K Q J
♣ A 6 5 2

Contract: 6NT
Lead: ♡10

West
♠ 8 7
♡ 10 9 8 5
♢ 9 8 4 2
♣ K J 8

East
♠ Q J 5 3
♡ 4 2
♢ 10 5 3
♣ Q 9 7 3

South
♠ A K 6 4
♡ A 7 6 3
♢ A 7 6
♣ 10 4

Waste Not, Want Not

Contract: 3NT
Lead: ♠Q

North
♠ A
♡ J 5 2
♢ 7 3 2
♣ 9 7 6 4 3 2

West
♠ Q J 10 4
♡ 8 7 6 3
♢ J 6
♣ Q J 5

East
♠ K 9 8 7
♡ Q 9
♢ 10 9 8 5 4
♣ K 10

South
♠ 6 5 3 2
♡ A K 10 4
♢ A K Q
♣ A 8

South had seven tricks off the top. His only chance to make 3NT was to win two additional tricks in hearts. He needed to finesse, so he led the ♡J at trick two. However, when East covered, South was able to win only the ace, king and ten.

South should have led dummy's ♡2 and finessed the ♡10. The ♡Q would have fallen under the ace on the second round of hearts, and declarer would still win *both* the jack and king.

Chapter 4

To Finesse
or Not to Finesse?

Some Important Suit Combinations

"When I take a fifty-fifty chance, I expect it to come off eight or nine times out of ten." The Hideous Hog

With no clues from the enemy, the issue here is how to give yourself the best chance to maximize your winners. It doesn't matter whether the suit is trumps.

Missing honor(s)	#cards between declarer/dummy	Example	Best % Play
Q	8	A 2 K J 6 5 4 3	Cash the ace, then finesse the jack.
Q and J	8	5 4 3 2 A K 10 9	Finesse the 10, hoping RHO holds the Q and J.
Q	9	A 3 2 K J 7 6 5 4	Do not finesse. Cash the ace and king.
K	10 or fewer	6 5 4 3 2 A Q J 10 9	Finesse. Do not play for the drop.
K	11	6 5 4 3 2 A Q J 10 9 8	Play for the drop by leading the ace.
K and Q	8 or 9	5 4 3 2 A J 10 9 (8)	Lead low to the J. If it loses, finesse the 10.
K and J	9	5 4 3 2 A Q 10 9 8	Finesse the queen. If it loses, cash the ace.
A and J	8	5 4 3 2 K Q 10 9	Lead low to the queen. If it loses, finesse the 10.
A and J	9	6 5 4 3 2 K Q 10 9	Lead low to the queen. If it loses, cash the king.

Hold That Finesse

"A finesse is a tool; and you don't use a tool without rhyme or reason, just because it happens to be lying about." Alfred Sheinwold

When it comes to finesses, a major philosophical difference separates the masses from the most accomplished players. Most players love to finesse. Finessing is simple – usually – and it provides immediate gratification (when it works).

However, **experts don't like to finesse;** never have and never will. Why? Finesses *lose* half the time. I compare the expert's mindset with that of a professional gambler. He certainly doesn't get rich on 50-50 propositions.

On the following deal, N-S bid well to reach slam. North's jump to 4♡ reassured you that you would not have a trump loser. So, with your gorgeous hand, you knew that 6♡ would be *at worst* on the club finesse.

Because of North's ♣J, slam is excellent. On any lead other than a diamond, there's no problem. You would draw trumps and be happy to take the club finesse. If the ♣Q loses to West's king, you will unblock your ♣A and get to the board to discard the ◇J on dummy's lovely ♣J.

Contract: 6♡
Lead: ◇K

North
♠ 5 4
♡ Q J 10 4
◇ 8 7 2
♣ J 7 6 5

South (You)
♠ A K Q
♡ A K 6 5 3 2
◇ A J
♣ A Q

West	North	East	South
—	—	Pass	2♣
Pass	2◇	Pass	2♡
Pass	4♡*	Pass	6♡
All Pass			

4♡* Promises a very weak hand with 4+ trumps, but no controls (ace, king, singleton or void) in the side suits.

Unfortunately, after the ◇K lead, you are faced with two possible losers – a diamond and a club. After drawing trumps, too many players settle for the club finesse. *You* deserve better than a 50/50 proposition.

Before reading on, take a good look at the N-S cards. Can you make the slam even if West has the ♣K?

Win the first diamond, and draw trumps with the ace
and queen. Now, cash your spades and discard a
diamond from dummy. Here is the layout after six
tricks have been played:

North
♠ —
♡ J 10
◇ 8
♣ J 7 6 5

South
♠ —
♡ K 6 5 3
◇ J
♣ A Q

You are now looking *mighty good.* Throw West in by
leading the ◇J from your hand. After winning the
◇Q, West is endplayed. A spade or diamond lead
allows you to ruff in dummy and sluff the ♣Q from
your hand.

If, as is likely, West leads a club, you know what to
do when playing last with your ♣AQ. If you found
this line of play, you will make this hand regardless of
which opponent was dealt the ♣K.

Here is the entire deal:

	North	
Contract: 6♡	♠ 5 4	
Lead: K♢	♡ Q J 10 4	
	♢ 8 7 2	
	♣ J 7 6 5	

West		East
♠ 9 7 6 3 2		♠ J 10 8
♡ 8		♡ 9 7
♢ K Q 10 3		♢ 9 6 5 4
♣ K 4 3		♣ 10 9 8 2

	South	
	♠ A K Q	
	♡ A K 6 5 3 2	
	♢ A J	
	♣ A Q	

West	North	East	South
—	—	Pass	2♣
Pass	2♢	Pass	2♡
Pass	4♡	Pass	6♡
All Pass			

Go With the Odds

Here's an opportunity for a finesse. Would you take it?

Contract: 4♠
Lead: ♡K

North
♠ 8 7 5 2
♡ J 3 2
♢ 6 2
♣ A Q 4 3

South
♠ A K Q J 9
♡ 7 6 5
♢ A Q
♣ K 6 5

West	North	East	South
—	Pass	Pass	1♠
Pass	2♠	Pass	4♠
All Pass			

West led the ♡K, and East signaled with the 9. West led the ♡8 to East's ace, and East shifted to the ♢5. You are now at the crossroads. To finesse or not to finesse, that is the question. What would you do?

The defenders have six clubs, which rate to divide 4-2. Therefore, dummy's fourth club is probably not going to win a trick. Accordingly, you should take the diamond finesse and hope for the best.

What a Difference a Club Makes

Now, try this "very similar but different" deal:
Same auction, same lead. You'll note that the only
difference is that instead of having the ♠2, North
now has the ♣ 2.

Contract: 4♠
Lead: ♡K

North
♠ 8 7 5
♡ J 3 2
◇ 6 2
♣ A Q 4 3 2

South
♠ A K Q J 9
♡ 7 6 5
◇ A Q
♣ K 6 5

West led the ♡K, and East signaled with the 9. West
led the ♡8 to East's ace, and East shifted to the ◇5.
Once again, the spotlight is on you.

This time, the defenders have only five clubs,
which is a huge difference. Normal bridge probability
suggests that their clubs are probably divided 3-2.
In addition, you have the inference that if West had
a singleton club, he probably would have led it.
Therefore, the correct play on this deal is to win the
◇A, draw trumps, and expect to run clubs.

The Practical Approach

The recommended way to play a suit may not be the best way to play the hand.

Contract: 6♡
Lead: ◊J

North
♠ A Q 7 5 3 2
♡ 10 3
◊ 7 6
♣ 8 5 4

South
♠ K 8
♡ A K J 9 8 6
◊ A Q
♣ A K 3

After the friendly diamond lead, your only possible losers are a club and a heart.

"Eight ever, nine never" suggests that with eight cards missing the queen, your best chance to avoid losing a trick is to finesse. However, crossing to dummy in spades to take the heart finesse would block spades and risk a ruff. Instead, you should cash the ♡AK.

If the ♡Q does not fall, continue hearts until the defender takes his winner. Even if a defender started with four or five hearts, no problem. You'll draw his trumps, cash dummy's spades, and discard the ♣3.

Chapter 5

YOU *Can* Execute an Endplay

Avoiding a Misguess

If you don't like finesses that lose, an endplay can be invaluable. Suppose you have this side suit:

North
♠ K 10 6

South
♠ A J 4

If either defender leads this suit, you'd be delighted. Regardless of which opponent held the queen, you would be assured of winning all three tricks based on the very sound principle **"last is best."**

However, without a favorable lead, you must tackle this suit yourself and try to guess who has the queen. On some hands, there are clues available from the bidding or earlier play. But, on many other hands, it's just a blind guess.

If the stars are not aligned or your ESP is out of sync, sometimes your finesse will lose, and you won't make your contract. This is especially frustrating because someone (either friend or foe) will be sure to point out that you could have made the hand, if you'd only "gone the other way." Yuck. That's no fun.

There must be a better way. Endplays – here we go.

North

Contract: 4♡ ♠ K 10 6
Lead: ♣10 ♡ K Q 8 5
 ◇ A 9
 ♣ 6 5 4 3

South
♠ A J 4
♡ A J 7 4 3 2
◇ Q 3
♣ J 2

East wins the club lead and continues clubs.
You carefully ruff the third round with the ♡J, but
West follows with a club. Before reading on, how do
you like your chances? If you are confident, would
you be willing to bet $10 against a doughnut?

Even if you're not a hungry gambler, you can afford
to make this bet. You have a sure thing. Draw trumps
ending on the board, then ruff dummy's last club to
eliminate that suit.

At this point, the stage is set. Lead the ◇3 to the ace,
and throw E-W in with your inevitable diamond loser.
The defender who wins the ◇K will be endplayed.
If he leads another diamond, you'll ruff in one hand
and sluff a spade from the other. If, as is likely, he
leads a spade, your spade problems are over. Who's
got the queen? It doesn't matter – you're home free.

Not All Opponents are Created Equal

	North
Contract: 4♠	♠ 10 7 2
Lead: ♡K	♡ A 4
	◇ 9 8 6 4 2
	♣ A K Q

South
♠ A K 6 5 4 3
♡ J 9
◇ K 7
♣ J 7 2

West	North	East	South
—	—	—	1♠
Pass	2◇	Pass	2♠
Pass	4♠	All Pass	

You win West's ♡K with the ace and lead a spade
to the ace. Everyone follows, so you cash the ♠K.
You'd like a 2-2 split, but E-W's trumps divide 3-1.

Question 1: Do you care which defender has
the last trump?

Question 2: If East has the last trump, what are your
chances, and how will you play?

Question 3: If West has the last trump, what are your
chances, and how will you play?

Question 1: Do you care which defender has the last trump?

Answer: Absolutely! You will be *much happier* if East has the last trump.

Question 2: If East has the last trump, what are your chances, and how will you play?

Answer: Your chances are excellent. Lead clubs and try to cash three rounds. If East follows, lead a heart to your jack. When West wins that with the ♡Q, he is endplayed – forced to lead diamonds around to your king or give you a ruff-sluff.

If East ruffs and leads a diamond, you will shrug and finesse the king and hope for the best.

Question 3: If West has the last trump, what are your chances, and how will you play?

Answer: Your chances are not great. Unless West is *very* obliging, you need East to have the ♢A.

At this point, you should lead a trump. West should lead a club or cash the ♡Q and exit with a heart or a club. If he does, you will lead a diamond towards the king and hope that the finesse will win.

However, if West is asleep or happens to panic and leads a diamond, you'll be a very happy camper.

As you can see, on the actual hand, your prayers are answered. East has the last spade, and clubs split normally, so E-W were ripe to be endplayed.

How did you do?

Here is the entire deal:

North

Contract: 4♠
Lead: ♡K

♠ 10 7 2
♡ A 4
◇ 9 8 6 4 2
♣ A K Q

West

♠ 8
♡ K Q 6 5 2
◇ A 5 3
♣ 9 8 6 4

East

♠ Q J 9
♡ 10 8 7 3
◇ Q J 10
♣ 10 5 3

South

♠ A K 6 5 4 3
♡ J 9
◇ K 7
♣ J 7 2

West	North	East	South
—	—	—	1♠
Pass	2◇	Pass	2♠
Pass	4♠	All Pass	

Everyone Loves a Good Strip

With an "iffy" suit, draw trumps and strip
your hand and dummy of any irrelevant suit(s).
Then, throw the enemy in with a sure loser.

	North
Contract: 4♠	♠ K J 9 8
Lead: ◇ K	♡ J 6 5
	◇ 9 8
	♣ A J 6 4

South
♠ A Q 10 7 6 5 2
♡ Q 7 4
◇ A 2
♣ 9

South was willing to lose one diamond trick and
two hearts. However, if he led hearts, he rated to
lose a third heart trick after the queen and jack were
captured by the ace and king.

Declarer needed to throw the defenders in with
his diamond loser and force them to lead hearts.
But – first things first: he had to get rid of *all* of
dummy's clubs.

Declarer won the diamond lead with his ace and led a club to dummy's ace. South ruffed a club with his ♠10, and led a trump to dummy's eight. Declarer ruffed another club with his ♠5, and led a spade to the nine. He then ruffed dummy's last club.

N-S had won the first seven tricks, which left:

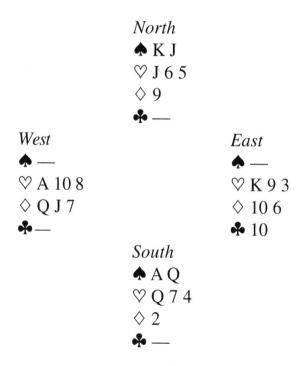

North
♠ K J
♡ J 6 5
◇ 9
♣ —

West
♠ —
♡ A 10 8
◇ Q J 7
♣ —

East
♠ —
♡ K 9 3
◇ 10 6
♣ 10

South
♠ A Q
♡ Q 7 4
◇ 2
♣ —

Declarer led the ◇2 and claimed. It did not matter which opponent won the trick. If that player led a minor, South would ruff in one hand and sluff a heart from the other. After a more likely heart return, declarer would play second hand low and lose only two heart tricks.

Last is Best

When you have a suit that you don't want to lead,
force the defenders to come to you.

	North	
Contract: 4♡	♠ A 9	
Lead: ♠K	♡ K J 7 5 4	
	◇ J 5 4 3	
	♣ K 3	

West		*East*
♠ K Q 6 3		♠ J 10 7 5 4
♡ 8 6		♡ 2
◇ A 10 9		◇ Q 7 2
♣ 10 6 5 4		♣ Q J 9 7

	South	
	♠ 8 2	
	♡ A Q 10 9 3	
	◇ K 8 6	
	♣ A 8 2	

If you lead diamonds, you could lose three tricks in
that suit. Because you have an inevitable spade loser,
that would be one too many. Win the ♠A, draw
trumps and eliminate your side's clubs by cashing the
king and ace and ruffing the third round. Then, exit
with dummy's ♠9. No matter how the E-W diamonds
are distributed, the defenders are endplayed – forced
to lead diamonds or give you a ruff-sluff. Voilà.

Chapter 6

Tricks of the Trade

Help Your Opponents Take the Bait

"If you don't give your opponents a chance to make mistakes, you cannot win."

Marty Bergen

Let's face facts. Most bridge players are dedicated honor-coverers. When declarer leads an honor through your average defender, he will invariably cover it whenever he has a higher honor. However, in many situations, **this is not the correct strategy.**

Instead, a defender's mindset should be: **Cover an honor with an honor ONLY when you have a realistic chance of promoting a card in your hand or partner's.**

Even if the defender knows not to cover, he will usually hesitate to think it over. Declarer is certainly entitled to draw inferences from the defender' actions. **In bridge, unlike poker, you can't hesitate for the sole purpose of deceiving your opponents.**

For the most part, only very good players can duck smoothly when an honor is led through them. Against these players, you cannot make assumptions. With everyone else, it is reasonable to assume:

1. If a defender has a higher card, he will usually either cover or hesitate before playing.

2. If a defender smoothly plays low, he probably does not have a higher honor.

Are you intrigued by this game within a game?
Food for thought. For now, I'd like to concentrate on
inducing covers in long suits. Suppose this is your
trump suit:

> *North* (dummy)
> Q 9 8 7
>
> *South*
> A J 10 6 5 3

Many players believe that it is correct to play the ace,
hoping to drop the singleton king. However, that's not
the percentage play. The best chance to avoid a loser
with 10 cards, missing the king, is to finesse.

Make sure that you lead the *queen* from dummy.
Most Easts will cover with the king whenever they
hold it, or pause to think, marking them with that card.
If an average player sitting East smoothly plays low,
assume that he does not have the king. At this point,
your only chance is to rise with the ace, hoping that
West's king is singleton.

On the other hand, a very good defender will plan
whether to "cover or not" as soon as dummy is tabled.
Therefore, when an expert East calmly plays low,
you cannot make any inferences. Instead go with the
odds and finesse.

North
Q 9 8 7 4

South
A J 10 6 5 3

With an 11th trump, it's correct to play for the drop.
Once again, lead the queen from dummy. Give the
people what they want: if East likes to cover, it would
be a shame to deny him the chance to do his thing.

Now try this one:

North
A 7 4 3

South
K J 10 9

This is an annoying two-way guess finesse. With eight
cards missing the queen, you should intend to finesse
("eight ever, nine never" is correct in general).
However, you can finesse either way, depending on
who you think has the queen. Sometimes the bidding
will provide clues; at other times you are on your own.

Try leading the jack. If West covers, your problems
are over. If he stops to think, assume he has the lady.
If he ducks smoothly, it is reasonable to assume that
East has the queen, so rise with the ace and finesse
through East. Against average opponents, you will
guess correctly *much more* than 50% of the time.

Here is another layout where you can take advantage
of your opponents' tendency to cover.

North
10 5 4 3

South
A 9 8 6 2

This suit looks boring. If the 4 missing cards divide
2-2, you will lose only 1 trick. However, if they divide
3-1, which is more likely, you will lose 2.

Now, watch the magic of: "where there's a coverer,
there's a way." After entering dummy in another suit,
lead the 10. If East has QJ7, KJ7, or KQ7 and makes
the mistake of covering, your ace will capture 2 honors
when West follows with his singleton honor. Not only
will you limit your losses to 1 trick, but you will enjoy
a psychological advantage on the next hand.

Do I suffer a twinge of conscience when profiting
from my opponents' errors? No, not at all. When I
played competitive tennis, I dreamed about concluding
a match with a spectacular winner. In reality, many of
my victories ended with an opponent's double fault.
I don't know how you would feel, but I slept just fine.

*"It's not enough to win the tricks that belong to you.
Try also for some that belong to the opponents."*
 Alfred Sheinwold

To Hold Up or Not to Hold Up?

Contract: 3NT
Lead: ♠7

North
♠ 9 6 5 4
♡ A J
◇ A K
♣ K Q J 10 4

South
♠ A 3
♡ K Q 2
◇ 9 7 4 2
♣ 7 5 3 2

West	North	East	South
Pass	1♣	Pass	1NT
Pass	3NT	All Pass	

South's 1NT response gave a good description of his hand. North loved his club suit, and jumped to game.

West led the ♠7, the four was played from dummy, and East played the ♠K. The spotlight was on South. To win or not to win, that was the question. Before reading on, what would you have done?

Question 1: Is dummy's ♠9 a significant card?

Question 2: Should you win the opening lead, or should you hold up?

Question 1: Is dummy's ♠9 a significant card?

Answer: Is it ever! More on this later.

Question 2: Should you win the opening lead, or should you hold up?

Answer: A hasty decision is *not* the way to go. Instead, do stop to figure out what's going on.

The first step is to apply the Rule of 11. Subtracting 7 from 11 equals 4, so North, East, and South have four cards above the 7 between them. N-S have 2 higher spades; the ace and the 9, so East must have 2 spades above the 7. He just played the king, so he still has one spade higher than the 7.

Is it possible to know more about East's other card? Yes, it is. West led fourth-best, so he has exactly three spades above the ♠7. If he had the ♠Q J 10, he'd have led the queen. Because he didn't, he can't have all three honors, so East's other spade above the 7 *must* be an honor.

You don't know whether the E-W spades are dividing 4-3 or 5-2. If spades are 4-3, you can't lose more than three spade tricks and the ♣A, so you should assume a 5-2 split. If East started with only two spades, his remaining honor is singleton. Because of dummy's ♠9, the spades are now blocked. Regardless of who has the ♣A, West will be unable to run his spades.

Finally, you're ready to play. Win the first trick with
the ♠A, and knock out the ♣A. Your contract is no
longer in jeopardy. West can lead a spade to East's
jack, but East is then out of spades. Or, West can cash
the ♠Q and 10, but dummy's ♠9 will then be high.
As long as spades are 5-2, your good technique will
be rewarded with an overtrick.

If you had made the mistake of holding up the ♠A,
you would have wasted the potential of dummy's ♠9.
East would return the ♠J to knock out your ace.
When West got in with the ♣A, he would cash his last
three spades, and down you'd go.

Here is the entire deal:

North
Contract: 3NT ♠ 9 6 5 4
Lead: ♠7 ♡ A J
 ◇ A K
 ♣ K Q J 10 4

West East
♠ Q 10 8 7 2 ♠ K J
♡ 8 7 5 4 ♡ 10 9 6 3
◇ Q 8 5 ◇ J 10 6 3
♣ A ♣ 9 8 6

South
♠ A 3
♡ K Q 2
◇ 9 7 4 2
♣ 7 5 3 2

Honesty is *Not* Always the Best Policy

When the opening leader is about to win the first trick, declarer should "signal" with a high card if *he* wants the suit continued.

The best way to induce your LHO to do what *you* want is to signal your attitude as if you were his partner. This deceptive play illustrates how declarer should try to mislead the defense.

<div align="center">

North
♡ 5 4 <u>3</u>

West *East*
♡ <u>A</u> K J 6 ♡ 10 8 <u>7</u>

South (You)
♡ Q 9 2

</div>

West leads the ♡A. If you play the ♡2, West knows that East's 7 is his lowest card, and that East does not want hearts continued.

That is not the message you want West to receive. You need West to continue hearts, and set up the ♡Q. The solution is to "signal" by playing your ♡9 – just as if you were West's partner and liked hearts.

Now, West is likely to believe that East started with ♡Q72 and continue the suit, which will set up your queen. Remember, a good player is both a partner to be trusted, and an opponent to be feared.

Chapter 7

Life in Notrump

The Rule of 11

When you think that your opponent has led 4th-best, you should subtract the value of the card led from 11. The difference represents the number of higher cards in the other 3 hands (excluding the opening leader).

Do not lose sleep trying to figure out why this works; just accept it. The following points are also worth knowing about the Rule of 11:

1. It does not apply when an honor is led.

2. Contrary to popular opinion, the Rule of 11 *does* apply in suit contracts, as long as the opening lead is fourth-best. The opening lead in a suit contract will often be made from a short suit, so declarer must proceed with caution.

3. The Rule of 11 "works" on any 4th-best lead, but high spot cards yield a lot more specifics about declarer's RHO's cards than lower cards.

4. The Rule of 11 applies on any 4th-best lead, not just the opening lead.

The Rule of 11 doesn't help the opening leader, but the information is crucial to his partner. Declarer can also benefit from the clues supplied by the Rule of 11. If he is alert, sometimes he can have the last laugh.

You're now ready to apply your Rule of 11 skills.

A Good Time to Say No to Second-Hand Low

After a non-honor opening lead is made in a notrump contract, declarer's first thought should be to apply the Rule of 11. This will occur more often in notrump, where short-suit leads are virtually non-existent.

The following deal illustrates how declarer can use the Rule of 11 to make his life easy. After the ♣6 is led, what card would you play from dummy at the first trick?

North

Contract: 3NT

♠ J 8 2

Lead: ♣6

♡ K J 8

♢ Q 8 5

♣ A 10 7 3

South (You)

♠ A K 6

♡ A Q 5

♢ 9 7 3 2

♣ Q J 4

West	North	East	South
			1NT
—	—	—	
Pass	3NT	All Pass	

Did you figure out that East has no club higher than the six? 11 - 6 = 5. Declarer and dummy account for five clubs greater than the six; thus, East cannot possibly beat dummy's ♣7.

You must win the first trick with the ♣7, and save your honors for later. Then it's easy to enter the South hand in hearts and finesse clubs. Eventually you will win four club tricks, regardless of when West plays his king. Along with two spades and three hearts, you will have four club tricks and your contract is in the bag.

If you carelessly played the ♣3 from dummy at the first trick, you'd have to waste an honor from your hand to win the trick. The club position would be:

North
♣ A 10 7

West　　　　　　　　　　*East*
♣ K 9 8 2　　　　　　　　♣ —

South
♣ Q 4

Unfortunately, there is no longer any hope for the fourth club trick as long as West is awake. He will be happy to cover if the queen is led. If declarer leads the four, West will insert the eight or nine.

Here is the entire deal:

Contract: 3NT
Lead: ♣6

North
♠ J 8 2
♡ K J 8
◇ Q 8 5
♣ A 10 7 3

West
♠ Q 9 5
♡ 10 6 3 2
◇ 6
♣ K 9 8 6 2

East
♠ 10 7 4 3
♡ 9 7 4
◇ A K J 10 4
♣ 5

South
♠ A K 6
♡ A Q 5
◇ 9 7 3 2
♣ Q J 4

West	North	East	South
—	—	—	1NT
Pass	3NT	All Pass	

If you know how to take nine tricks after playing the ♣3 at trick one (assuming correct defense), feel free to call me – collect.

Look Carefully Before You Leap

Contract: 3NT
Lead: ♡Q

North
♠ Q 3 2
♡ K 5 3
◇ J 5 4 2
♣ K J 3

South
♠ J 10 9 5
♡ A 4
◇ A K Q
♣ Q 10 9 4

West	North	East	South
—	Pass	Pass	1NT
Pass	2NT	Pass	3NT
All Pass			

North correctly downgrades his flat, aceless 10-count and only raises to 2NT, but you love your black-suit intermediate cards and carry on to game.

Words to the wise: Because of the diamond block, this hand is not as easy as it seems.

Very helpful hint: Do not duck the opening lead!

Question 1: In which hand will you win the ♡Q lead?

Question 2: Which suit will you lead next?

Question 3: Are you confident of making this hand against best defense?

Question 1: In which hand will you win the ♡Q lead?

Answer: When I use this deal in my classes, most of my students want to save the ♡K to get to the ◇J later. However, not only is that unnecessary, but there is a more important consideration.

Although it is far from obvious, you *must* win the opening lead on the board. You *need* to save the ♡A to ensure that you can get back to your clubs after unblocking the diamond suit. Otherwise, if an opponent is smart enough to hold up his ♣A until the third round, you'll have no entry to your fourth club.

Question 2: Which suit will you lead next?

Answer: Diamonds. You must unblock your AKQ. On most hands containing a blocked suit, you need to unblock the suit ASAP.

Question 3: Are you confident of making this hand against best defense?

Answer: Yes. As long as you win the ♡K and unblock diamonds, the defenders are helpless. You'll then lead a low club to the king. Regardless of which opponent holds the ♣A, *either* the ♣K or the ♣J *must* furnish you with the entry you need to cash the ◇J. And by saving the ♡A, even if an opponent holds up his ♣A, you're guaranteed to be able to get back to your hand to cash your fourth club.

Here is the entire deal:

North

Contract: 3NT ♠ Q 3 2
Lead: ♡Q ♡ K 5 3
♢ J 5 4 2
♣ K J 3

West	*East*
♠ A 7	♠ K 8 6 4
♡ Q J 10 6	♡ 9 8 7 2
♢ 9 7 6 3	♢ 10 8
♣ A 7 5	♣ 8 6 2

South
♠ J 10 9 5
♡ A 4
♢ A K Q
♣ Q 10 9 4

West	North	East	South
—	Pass	Pass	1NT
Pass	2NT	Pass	3NT
All Pass			

A Must to Avoid

Declarer must be careful to prevent the dangerous opponent from obtaining the lead.

On this deal, South must guard against East's getting in and leading through declarer's ♠K 8.

	North
Contract: 3NT	♠ Q
Lead: ♠7	♡ K Q 5
	◇ 7 4 3 2
	♣ A 10 9 4 3

South
♠ K 8 6
♡ A J 4
◇ A J 8 5
♣ K J 2

When the ♠Q wins the first trick, you know that West has the ♠A. If you ever lose a trick to East, a spade return will prove fatal. East is the danger hand, so you should execute an "avoidance play" to make sure that East (the bad guy) never gets the lead.

At trick two. lead the ♣10 and let it ride, perfectly willing to lose a trick to West – the safe opponent. You now have at least 9 sure tricks: 4 clubs, 1 spade, 3 hearts, and 1 diamond.

Chapter 8

Overcoming
Entry Problems
in Notrump

If You Don't Have Entries, You Ain't Got Nothing

"Failing to prepare is preparing to fail."
 Vince Lombardi, legendary football coach

If I had to single out the most important topic on cardplay, there is no question in my mind – entries. How many times have you heard someone lament about being "stuck in the wrong hand?"

On many deals, there is an opportunity to make a key play to ensure that declarer has the entries that he needs. Unfortunately, key plays are not always obvious. At that special moment, it would be nice if:

- A bell would go off;

- Someone would stand up and yell "alert!"

- A little bird would chirp "now" in your ear;

- A guardian angel would appear to protect you from yourself.

Alas, no such luck; declarer is always on his own.

Entry considerations are especially critical in notrump contracts when the trick source is in the weak hand.

Marty Sez: Declarer must make sure that at least one entry remains in the weak hand until the long suit is ready to run.

On the following deal, not only was declarer's key suit in the weak hand, but in addition, the suit blocked. Fortunately, declarer demonstrated that he needed no help with his key play.

"How could you play your ace on my king?" said the amazed dummy. "Trust me," declarer said, "I have a good plan." Indeed he did.

		North	
Contract: 3NT		♠ A 4 3 2	
Lead: ♠K		♡ K	
		◇ A Q J	
		♣ A Q 6 5 3	

West	*East*
♠ K Q J 9	♠ 10 8
♡ 7 5 4	♡ Q 6 3 2
◇ 9 8 6 2	◇ 5 4 3
♣ J 8	♣ K 10 9 2

	South
	♠ 7 6 5
	♡ A J 10 9 8
	◇ K 10 7
	♣ 7 4

West	*North*	*East*	*South*
—	1♣	Pass	1♡
Pass	2♠	Pass	2NT
Pass	3NT	All Pass	

West had an obvious spade lead, even though North had bid the suit. Although there are exceptions to almost everything, I have strong feelings about sequence leads. When I'm on lead and have a sequence in a suit, I think: "Thank you, Lord," for solving my potential opening lead dilemma.

Declarer allowed West to win the first trick with the ♠K, and won the spade continuation with dummy's ace. He could only count 7 winners: 1 spade, 1 club, 2 hearts and 3 diamonds. How should he proceed to guarantee the contract?

Declarer led the ♡K and overtook it with his ace, causing his partner to gasp. But, it was then easy to set up his hearts by forcing out the queen while the ◇K remained as the vital entry back to his hand.

It was crucial for South to overtake the ♡K with his ♡A. If he hadn't, there would be no way to win more than two heart tricks. Because he was still on the board, he would not have the two outside entries he needed; one to knock out the ♡Q and the other to re-enter his hand to run hearts. Without four heart tricks, declarer could not make 3NT.

"Well-played," said North after 3NT rolled home. "Would you like to play again?" You must admit – this dummy was no dummy.

Make Sure You Get There

"An entry, an entry, my kingdom for an entry."

	North
Contract: 3NT	♠ Q 7 2
Lead: ♠8	♡ 9 7 6 5
	◇ 6
	♣ K Q J 10 5

South
♠ A 10 5
♡ A K 3
◇ A K 5 3
♣ 9 8 3

West	*North*	*East*	*South*
Pass	Pass	Pass	1 ◇
1 ♠	Dbl	Pass	2NT
Pass	3NT	All Pass	

Declarer played low from dummy at trick one, as did East. South gratefully scooped up the trick with his ♠10, and went to work on dummy's lovely club suit.

Unfortunately, when East held up his ♣A until the third round and returned a spade, dummy's ♠Q was *not* an entry. Declarer had no way to get to dummy's two club winners, and had no chance for a ninth trick.

Declarer erred at trick one when he won his ♠10. Once he did that, dummy's ♠Q was *not* going to be an entry to dummy's club winners.

From the bidding (and Rule of 11), it was clear that West held the ♠K. Therefore, South should have won the first trick with his ♠A. Once that card was out of the way, it would have been easy to enter dummy with the well-placed ♠Q after knocking out the ♣A.

Here is the entire deal:

North

Contract: 3NT ♠ Q 7 2
Lead: ♠8 ♡ 9 7 6 5
 ♢ 6
 ♣ K Q J 10 5

West *East*
♠ K J 9 8 3 ♠ 6 4
♡ Q 10 2 ♡ J 8 4
♢ Q 9 7 2 ♢ J 10 8 4
♣ 7 ♣ A 6 4 2

South
♠ A 10 5
♡ A K 3
♢ A K 5 3
♣ 9 8 3

Making the Most of Your Intermediates

Contract: 6NT
Lead: ◇Q

North
♠ 6 5 3
♡ 10 9 4
◇ K 4
♣ A 8 7 4 2

South
♠ A K 2
♡ A K Q J
◇ A 6 5 3
♣ K Q

West	*North*	*East*	*South*
—	—	—	2♣
Pass	2◇*	Pass	3NT
Pass	6NT	All Pass	

2◇* = a waiting bid

Because of the lack of entries to dummy, 6NT is not a good contract. Either 6♣ or 6♡ would have been much better.

Was there an easy way to bid slam in one of your 7-card fits? I do have some ideas. However, let's save that for later. Now is *not* the time to allow your mind to wander.

You count your sure winners: 2 spades, 4 hearts, 2 diamonds, and 3 club tricks (as long as you save the ◇K as an entry to the ♣A). Neither spades nor diamonds are going to yield an extra trick, so it's clubs or bust. If you are lucky enough to get a 3-3 club split, you'll promise not to complain about anything for a month.

You carefully win the ◇A, and cash the ♣K. West follows with the ♣9 and East plays the ♣3. You lead the ♣Q and West follows with the ♣J. TIME OUT! Because of North's ♣8 7, don't you dare play low from dummy. The sky is no longer dark and gloomy; out of nowhere a gorgeous rainbow has appeared. **You must overtake the ♣Q with dummy's ace.**

After you overtake, here are the remaining clubs:

```
              Dummy
              ♣ 8 7 4     East
   ♣ —                    ♣ 10 6
              ♣ —
```

You are now on the board, and can continue clubs by leading dummy's ♣8. East can win with the ♣10, but your troubles are over. The well-preserved ◇K is still on the board, and will enable you to capture East's ♣6 with dummy's ♣7. Then, you can triumphantly win the ♣4 for your fourth club winner, and more importantly, your 12th trick.

Here is the entire deal:

```
                    North
                    ♠ 6 5 3
                    ♡ 10 9 4
                    ◇ K 4
                    ♣ A 8 7 4 2
West                              East
♠ Q 10 8 4                        ♠ J 9 7
♡ 8 3                             ♡ 7 6 5 2
◇ Q J 10 8 7                      ◇ 9 2
♣ J 9                             ♣ 10 6 5 3
                    South
                    ♠ A K 2         S       N
                    ♡ A K Q J       2♣      2◇
                    ◇ A 6 5 3       ???
                    ♣ K Q
```

As to how you could have arrived at a better slam:
I don't know of a *logical* way to reach 6♣, where it's
easy to win four club tricks (while losing one) without
overtaking. But, I do believe that 6♡ was biddable.

After the 2◇ response, South did not have to rush to
bid 3NT. If he had appreciated his great heart suit
and bid 2♡, North would have been happy to raise.
Remember: **"A suit with 100 honors can be treated
as if it contained an extra card,"** as well as
"When in doubt, make the cheapest sensible bid."

By ruffing two diamonds with dummy's ♡10 9,
6♡ would be easy to make.

Chapter 9

Drawing Trumps:
All, Some, or None

When in Doubt – Don't

Perhaps the most popular bridge misconception is:
"In a suit contract, declarer should immediately draw
trumps." Why do so many believe this? Is it because:

- They can't forget the contract that was lost
 when they didn't draw trumps – and a defender
 trumped one of their winning tricks.

- Their friends taught them that the first thing to
 do is "get the kiddies off the street."

- Their first bridge teacher gave them very easy
 hands, in which they didn't have to do anything,
 except draw trumps and take their tricks.

Is this correct? No way! The truth is: **it is usually
wrong to draw trumps ASAP.** In fact, I would
estimate that declarer should draw trumps first only
40% of the time.

It would be absurd to say that drawing trumps first is
never correct. However, there are many reasons to
postpone pulling trump. Here are a few:

- You need to ruff losers in dummy.

- You must preserve trump entries in order to
 develop a long suit or set up an endplay.

- You are eager to set up a side suit on which
 you will discard losers.

Dummy's Ruff Can Be Smooth

"Shortness is in the eye of the beholder."
 Wee Willie Keeler, legendary oldtime baseball player

Not enough players appreciate how critical it is to win tricks by ruffing with *dummy's* trumps. In fact, sometimes you can do so even when dummy does not have a short suit!

On the following deal, declarer was not impressed with any of dummy's suits.

	North
Contract: 4♠	♠ Q J 6
Lead: ◇ Q	♡ 8 6 5
	◇ 7 6 3
	♣ A 8 7 2
	South
	♠ A K 10 9 8
	♡ A 7 3 2
	◇ A K
	♣ 4 3

West	*North*	*East*	*South*
—	Pass	Pass	1♠
Pass	2♠	Pass	4♠
All Pass			

Declarer won the diamond lead and drew trumps in three rounds. He then turned his attention to hearts, hoping for a 3-3 split. But, after the normal 4-2 heart split, declarer finished with the same 9 winners he started with. However, he could have made 4♠.

Dummy is not *short* in hearts – but he does have fewer than declarer does. Therefore, declarer should trump one of his heart losers in dummy for the 10th trick.

Use good crossruff technique by taking your side-suit winners first.

Trick 1: Win your ◇A.

Trick 2: Lead your ◇K.

Trick 3: Lead a club to the ace.

Trick 4: Lead a heart to your ace.

Trick 5: Concede a heart trick.

Trick 6: Win the likely trump return in your hand. No other defense would affect the outcome.

Trick 7: Concede a second heart, creating a void in dummy (*finally*).

Trick 8: Win the trump return in your hand.

Trick 9: Ruff your losing heart with dummy's ♠Q.

Más vale tarde que nunca. That translates to *better late than never*, which is all I remember from three years of high school Spanish.

At this point, you have won 7 tricks, and still have
3 winning trumps in your hand. Trumping a heart
on the board increased your 5 trump winners to 6,
which goes very nicely with your 4 side-suit winners.
All you lose is 1 club and 2 hearts.

Here is the entire deal:

North

Contract: 4♠ ♠ Q J 6
Lead: ◇Q ♡ 8 6 5
 ◇ 7 6 3
 ♣ A 8 7 2

West *East*
♠ 7 5 4 ♠ 3 2
♡ K J ♡ Q 10 9 4
◇ Q J 10 8 ◇ 9 5 4 2
♣ Q 9 6 5 ♣ K J 10

 South
 ♠ A K 10 9 8
 ♡ A 7 3 2
 ◇ A K
 ♣ 4 3

West	*North*	*East*	*South*
—	Pass	Pass	1♠
Pass	2♠	Pass	4♠
All Pass			

Save One For Later

	North
Contract: 4♠	♠ 7 5 2
Lead: ♡10	♡ A 7 4
	◇ A K 3
	♣ Q J 3 2

South
♠ A K Q J 10 6
♡ J 6
◇ 8 7 4
♣ 8 4

West	*North*	*East*	*South*
—	—	—	1♠
Pass	2♣	Pass	2♠
Pass	4♠	All Pass	

After your light opening bid, you arrive in 4♠.
3NT would have been easier, but you hope to make
something out of dummy's clubs. That's your only
chance for a tenth trick.

Question 1: Do you win the first trick?

Question 2: Once you begin drawing trumps, if they
split 3-1, should you draw three rounds?

Question 1: Do you win the first trick?

Answer: YES! Playing low would give East the opportunity to shift to diamonds. The defense would then have the timing to set up *their* diamond trick before you had a chance to set up *your* club trick. With your inevitable two club losers and one heart loser, you can't afford to also lose a diamond trick.

At trick two, you lead a trump to your hand. Both defenders follow. You cash a second trump, but East discards a heart.

Question 2: Once you begin drawing trumps, if they split 3-1, should you draw three rounds?

Answer: NO! You can't afford to. You need to keep a trump in dummy so you can easily get back to your hand later on. In order to build a club trick, you will need to lead them *twice* from your hand.

You lead a club to the queen, and East wins the king. He returns the ◇J, and you win with dummy's king.

You lead a trump to get back to your hand, which also pulls West's last trump. You now lead your last club. As long as the opponent's club honors are split, you will be able to win dummy's ♣J for your tenth trick.

Here is the entire deal:

	North
Contract: 4♠	♠ 7 5 2
Lead: ♡10	♡ A 7 4
	◇ A K 3
	♣ Q J 3 2

West	*East*
♠ 9 4 3	♠ 8
♡ 10 9 8 2	♡ K Q 5 3
◇ Q 6 5	◇ J 10 9 2
♣ A 10 7	♣ K 9 6 5

	South
	♠ A K Q J 10 6
	♡ J 6
	◇ 8 7 4
	♣ 8 4

West	*North*	*East*	*South*
—	—	—	1♠
Pass	2♣	Pass	2♠
Pass	4♠	All Pass	

The Meek Shall Inherit the Earth

The fact that your trump suit is weak should not prevent you from drawing them.

	North
Contract: 4♠	♠ 8 5 3 2
Lead: ♡J	♡ 4
	◇ A K J 10
	♣ K 6 4 2

South
♠ 9 7 6 4
♡ A K Q
◇ Q 8 6 5
♣ A J

West	*North*	*East*	*South*
—	—	—	1NT
Pass	2♣	Pass	2♠
Pass	4♠	All pass	

Your spades are not pretty, but it would be crazy to risk ruffs by not drawing trumps ASAP. Other than trumps, your hands contain nothing but winners.

As long as spades divide 3-2, all you will lose is three spade tricks. If spades divide 4-1, even Houdini couldn't make the hand.

Chapter 10

Timing
is Everything

Maximizing Communication

Contract: 4♠

Lead: ◇ 10

North

♠ 10 9 8 6

♡ A Q J 10

◇ A J

♣ 8 6 4

South

♠ A K Q 4 3

♡ 9 8 2

◇ 4 2

♣ K 3 2

West	North	East	South
—	1♣	Pass	1♠
Pass	2♠	Pass	4♠
All Pass			

Question 1: Is this the time to "lose your losers early?"

Question 2: If East has the ♡K and West has the ♣A, how many tricks do you expect to lose?

Question 3: If the opponent's trumps divide 3-1, how many rounds of trumps will you draw immediately?

Question 1: Is this the time to "lose your losers early?"

Answer: Absolutely not. If you play second hand low, East will win the ◇Q and fire back the ♣Q, and you will lose the first four tricks before you get started.

Question 2: If East has the ♡K and West has the ♣A, how many tricks do you expect to lose?

Answer: Five. 3 club tricks, 1 diamond, and 1 heart, and there's absolutely nothing you can do about it.

Question 3: If the opponent's trumps divide 3-1, how many rounds of trumps will you draw immediately?

Answer: Only one! If West has the ♡K, you want to win four heart tricks so you can discard a loser on the fourth heart. This could require three finesses. The necessary three entries are available with your ♠AKQ **as long as you use each one to finesse.** It would be a shame to find West with the ♡K, and not be able to take three finesses because you wasted your entries.

Therefore, the drawing of trumps must be postponed. Because the opponents are not likely to ruff anything, this is not a problem. Now that you've finished planning, you're ready to play.

Win the diamond lead and lead a spade to your ace. Take the heart finesse. It wins. All right. You lead a second trump to your king as West shows out. Ignore East's last trump and take a second heart finesse.

When the finesse wins, it is easy to return to your hand with the ♠Q, which draws the last trump. You're now in your hand to take a third winning heart finesse. Cash the ♡A and discard your last diamond.

Because the ♣A is offside, you will lose three club tricks, but the rest are yours.

A successful finesse is always nice, but good timing is the name of the game.

Here is the entire deal:

North

Contract: 4♠
Lead: ◇10

♠ 10 9 8 6
♡ A Q J 10
◇ A J
♣ 8 6 4

West

♠ 5
♡ K 6 4 3
◇ 10 9 8 7 5
♣ A 7 5

East

♠ J 7 2
♡ 7 5
◇ K Q 6 3
♣ Q J 10 9

South

♠ A K Q 4 3
♡ 9 8 2
◇ 4 2
♣ K 3 2

Quality, Not Quantity

As South, can you take 10 tricks on the deal below?

Contract: 4♠
Lead: ♡Q

North
♠ 5 3 2
♡ 5 4 2
◇ K Q
♣ K J 10 9 4

West
♠ A K
♡ Q J 10
◇ J 9 5 4 3
♣ 8 7 5

East
♠ 6 4
♡ 8 7 6 3
◇ A 10 8 7 6
♣ 3 2

South
♠ Q J 10 9 8 7
♡ A K 9
◇ 2
♣ A Q 6

West	North	East	South
Pass	Pass	Pass	1♠
Pass	2♠	Pass	4♠
All Pass			

You are confronted with four possible losers: 2 spade tricks, 1 heart, and 1 diamond. Clearly, you can't do anything about the ♠AK. The diamond loser is also inevitable, unless the opponents forget to take their ace. **Therefore, you must focus your attention on avoiding the heart loser.**

Some players are overly impressed with the N-S clubs. They immediately lead trumps, planning to discard their ♡9 on dummy's club winners. This plan is destined to fail.

Give it a try. You win the heart and play a trump. West takes the ♠K and continues with a second heart. You win and play a second trump, giving West the lead. He cashes the ♡10 and shifts to a diamond. Down one. No, after the heart lead, planning to use dummy's clubs is not the way to go.

The correct line of play is as follows:

Trick 1: Win the ♡Q lead with the ace.

Trick 2: Lead a diamond to the king and ace. You need to develop a diamond winner; until you force out the ace, dummy's diamonds are worthless.

Trick 3: Win East's heart return with your king.

Trick 4: Lead the ♣6 to the board.

Trick 5: Cash dummy's ◊Q, discarding the ♡9 from your hand.

Trick 6: Now, and only now, you are ready to draw trumps.

Playing Double Dummy

The highest compliment you can pay a player is:
"He played that hand double dummy." *The Official
Encylopedia of Bridge* defines double dummy as:
"play of a hand that could not be improved upon,
as though declarer were looking at all four hands."

Here's your opportunity to play double dummy.
The question is, with all four hands in view, can you
make the ridiculous, hypothetical 7♠ doubled contract
with the equally idiotic ♡J lead? The solution is
provided on the next page. Because your sides is
vulnerable, if you succeed, your score if playing
duplicate will be a juicy +2470.

North

Contract: 7♠ Dbl ♠ A K 2
Lead: ♡J ♡ Q 4 3
◇ A 7
♣ A 9 7 5 3

West *East*

♠ — ♠ J 9 7 5 4 3
♡ J ♡ K 9 7 5
◇ K Q J 10 9 3 ◇ 8 6
♣ K Q J 10 8 2 ♣ 6

South

♠ Q 10 8 6
♡ A 10 8 6 2
◇ 5 4 2
♣ 4

Do not waste even one second wondering how or why N-S bid a grand slam. Obviously, this is not a normal deal from real life. Instead, it is a deal that was constructed by a bridge expert with too much time on his (or her) hands.

Trick 1: ♡J, Q, K, A (it would not help East to duck).

Trick 2: ◇2 to dummy's ace
(a club to the ace is also okay).

Trick 3: ♡3, 5, 6, West discarding a minor.

Trick 4: ♣4 to dummy's ace.

Trick 5: ♡4, 7, 8, West discarding a minor.

Trick 6: ♡10, discarding dummy's ◇7,
West discarding a minor.

Trick 7: Ruff your ◇4 in dummy with the ♠2.

Trick 8: Lead dummy's ♣3, overruffing East.

Tricks 9-13: Crossruff the last 5 tricks. At tricks 9 and 11, East will be forced to underruff when you ruff high with North's trumps. At tricks 10 and 12 you'll use your own trumps to overruff East. Making 7.

That will teach the opponents to double you!

If at First You Don't Succeed...

		North	
Contract: 6♠		♠ 10 7 3 2	
Lead: ♣J		♡ A K Q J 10	
		◇ A 4	
		♣ Q 6	

West	*East*
♠ A	♠ 6 5
♡ 8 5 3 2	♡ 6 4
◇ J 9 2	◇ Q 10 8 6 5
♣ J 10 9 5 3	♣ K 7 4 2

	South
	♠ K Q J 9 8 4
	♡ 9 7
	◇ K 7 3
	♣ A 8

West	*North*	*East*	*South*
—	1♡	Pass	1♠
Pass	3♠	Pass	4NT
Pass	5♡	Pass	6♠
All Pass			

The ♣J lead was covered by the queen, king and ace.
Declarer needed to dispose of his ♣8 on North's
hearts, and hoped for a 3-3 split. Unfortunately, East
ruffed the third heart with his ♠5. South overruffed
and led his ◇3 to dummy's ace. East ruffed the 4th
heart, but South overruffed. Declarer cashed the ◇K
and ruffed his ◇7. He then led dummy's last heart,
discarded his club loser, and conceded a trick to the
one remaining trump, the ♠A. Making six.

Chapter 11

Counting Winners
in Suit Contracts

Winning Your Small Trumps

Bridge players are taught to "count winners in notrump, but count losers in a suit contract." Although this is good advice, sometimes, counting winners in a suit contract can be more helpful.

	North
Contract: 4♠	♠ A K Q
Lead: ♡Q	♡ 7 5 4
	◇ 9 4 3
	♣ 8 5 3 2

South
♠ 7 6 5 4 2
♡ A K 6
◇ A K 7 5
♣ A

Declarer won the heart lead and began drawing trumps. He was very disappointed to see West show out on the second round. South then turned his attention to diamonds, hoping for a 3-3 split which would enable him to set up his fourth diamond. But, when that suit divided 4-2, he was unable to win 10 tricks.

South was unhappy and unlucky. The question is, was he also unwise? Before reading on, consider whether or not a tenth trick was available.

Declarer could have done better. He had eight winners in high cards: ♡AK, ◊AK, ♣A and ♠AKQ. If spades divided 3-2, declarer's last two trumps would be good. In fact, if the opponent's diamonds split 3-3, South would have been able to make an overtrick. However, if neither suit split, the only way to win two additional tricks would be to ruff twice in his hand.

When it costs nothing to guard against bad splits, good players take precautions. After winning the heart lead with his ace, South should cash his ♣A. *Then,* he can lead a spade to the board, and ruff a club.

Here is the best continuation:

Trick 5: Cash the ◊A.

Trick 6: Lead a spade to dummy. If both follow, draw the last trump. 10 tricks are now assured, and you can work on diamonds and try to make five. However, when West shows out:

Tricks 7-8: Lead a diamond to your king and cash your ♡K.

Trick 9: Lead a spade to dummy's last honor.

Trick 10: Lead a club and ruff it with your last trump for your tenth trick.

Here is the entire deal:

Contract: 4♠
Lead: ♡Q

North
♠ A K Q
♡ 7 5 4
◇ 9 4 3
♣ 8 5 3 2

West
♠ 9
♡ Q J 10 3
◇ Q 10 8 2
♣ Q 10 7 6

East
♠ J 10 8 3
♡ 9 8 2
◇ J 6
♣ K J 9 4

South
♠ 7 6 5 4 2
♡ A K 6
◇ A K 7 5
♣ A

West	North	East	South
Pass	Pass	Pass	1♠
Pass	2♠	Pass	4♠
All Pass			

Lose Now – Win Later

Good players are *not* grabbers. They don't mind
losing a trick or two in order to give themselves the
best chance to make the hand. Unfortunately, too
many players are so eager to win the next trick that
they forget all about the big picture.

On this deal from the past, I was giving a playing
lesson to an experienced Life Master. I watched as he
took a line of play that risked the contract. He was in
such a hurry to get rid of his club loser that he forgot
about what he needed to do with his diamonds.

	North (Marty)
Contract: 4♠	♠ A K 6
Lead: ♣K	♡ A 10 9 5 3
	◇ 5
	♣ 9 6 4 3

South
♠ Q J 9 5 4
♡ K
◇ J 8 7 4 3
♣ A 7

West	North	East	South
—	1♡	Pass	1♠
Pass	2♠	Pass	4♠
All Pass			

The raise to 2♠ would not be everyone's choice, but
AK6 in partner's major looked awfully good to me.
Anyway, on to the play.

Declarer could not wait to get rid of his ♣7. He won the ♣A and cashed his ♡K. Then, he *led a trump* to dummy's ♠A and happily cashed the ♡A, discarding his club loser. He continued by leading dummy's ◊5 to create a void. West won the diamond, and correctly shifted to a trump to stop the crossruff. Declarer won the trump return in his hand and ruffed a diamond with dummy's last trump.

After seven tricks were played, here is the position with North on lead:

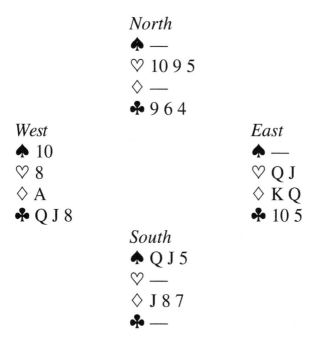

North
♠ —
♡ 10 9 5
◊ —
♣ 9 6 4

West
♠ 10
♡ 8
◊ A
♣ Q J 8

East
♠ —
♡ Q J
◊ K Q
♣ 10 5

South
♠ Q J 5
♡ —
◊ J 8 7
♣ —

South had lost only one trick, but the hand could no longer be made. Dummy's diamond void was worthless because he was trumpless. South won his three trumps, but lost the ◊J87 – down one.

Declarer should have been grateful that the opening lead wasn't a trump, and concentrated on winning 10 tricks. This could have been a classic crossruff hand; and the last thing declarer ever wants to do on a crossruff is lead trumps. South should have counted winners as follows: 2 hearts and the ♣A represented 3 tricks in the side suits. 5 trump winners in his hand brought the total to 8. Two ruffs in dummy? No problem. Here's what should have happened:

After winning the ♣A, South leads a diamond at trick two. West wins and should shift to a trump. It would be wrong for West to try to cash a club because declarer might be void. Instead, West must get rid of a trump from each of the N-S hands.

South should continue as follows:

Trick 3: Win West's trump shift with the ♠A.

Trick 4: Lead a heart to the king.

Trick 5: Trump a diamond with the ♠6 in dummy.

Trick 6: Cash the ♡A, discarding the ♣7.

Trick 7: Trump a club with the ♠5.

Trick 8: Trump a diamond with dummy's ♠K.

Trick 9: Trump a club with the ♠9.

Declarer has now won 8 tricks and is sitting pretty with the ♠QJ.

Here is the entire deal:

Contract: 4♠
Lead: ♣K

North (Marty)
♠ A K 6
♡ A 10 9 5 3
◇ 5
♣ 9 6 4 3

West
♠ 10 3 2
♡ 8 7 2
◇ A 10 9
♣ K Q J 8

East
♠ 8 7
♡ Q J 6 4
◇ K Q 6 2
♣ 10 5 2

South
♠ Q J 9 5 4
♡ K
◇ J 8 7 4 3
♣ A 7

West	North	East	South
—	1♡	Pass	1♠
Pass	2♠	Pass	4♠
All Pass			

This deal was played in a team match, and I expected to lose a game swing. What happened at the other table? Our teammate also led the ♣K against 4♠. However, the Life Master declarer played the hand exactly the same way that my partner did! If only I had been playing with *you*.

Making the Most of an Opportunity

When playing a slam, counting winners is often more helpful than counting losers.

Contract: 6♡
Lead: ♠4

North
♠ A 7 6 5 3
♡ 5
◇ Q J 9 5 4 3
♣ 10

South
♠ Q
♡ A K Q J 10 8 6
◇ A
♣ A 7 6 2

After some serious overbidding, you arrive in the outrageous contract of 6♡. Don't despair; trust me, I've been in worse.

Before playing a card, stop and count your winners: You have 7 heart tricks, 3 side aces and a club ruff in dummy. That's 11. Your only hope for a 12th trick is that West led away from the ♠K, so that your ♠Q will win a trick. Play low from dummy and say a prayer.

Lo and behold, East plays the ♠J! Yes!! You win your queen, cash the ♣A, and ruff a club. You then discard another club on the ♠A. All you lose is your last club. All's well that ends well.

Chapter 12

Pesky Partscores

Looking For Eight Tricks

One of the best times to count winners in a suit contract is when declaring a partscore. Because of your limited resources, making a modest number of tricks can often prove to be more difficult than bringing home a game or slam. Here's a case in point.

	North
Contract: 2♣	♠ K Q 8 6 4
Lead: ♣3	♡ 9 8 6 2
	◇ 8
	♣ 10 7 5

South
♠ 2
♡ J 5 3
◇ A J 7 6 3
♣ A K Q J

West	North	East	South
—	Pass	Pass	1◇
Pass	1♠	Pass	2♣
All Pass			

Question 1: What are your prospects for taking eight tricks?

Question 2: After winning the opening trump lead, what would you lead at trick two?

Question 1: What are your prospects for taking eight tricks?

Answer: Not great! You don't have enough fast entries to your hand to ruff two diamonds as well as set up your fifth diamond. Therefore, you'll need to do something with dummy's spade honors. And you must work on that suit *immediately.*

If you make the mistake of *first* playing the ♢A and ruffing a diamond on the board *before* playing spades, you'll be in trouble. When you then lead spades, the defender will win his ♠A and lead a second trump, removing dummy's last trump. You won't be able to get to the board, and will have no chance to win eight tricks.

Question 2: After winning the opening trump lead, what would you lead at trick two?

Answer: Lead your ♠2 and hope West has the ♠A. If he does, he has no good options. If he wins the ♠A and leads another trump, you can win and play the ♢A and ruff a diamond with dummy's last trump. You'll then be able to cash both the ♠K and the ♠Q.

If West ducks the ♠2, you will win dummy's ♠K. *Now*, you will be able to crossruff. You'll lead the ♢8 to your ace and ruff a diamond with the ♣7. You can then ruff a spade to your hand, and ruff another diamond with dummy's ♣10.

If East has the ♠A, you're going down. East will
capture dummy's ♠K and lead a second trump.
You'll cash the ◇A, ruff the ◇3, and cash the ♠Q, but
you'll still fall one trick short. Your only satisfaction
will be in knowing that you played the hand correctly,
giving yourself the best chance to make the contract.

Here is the entire deal:

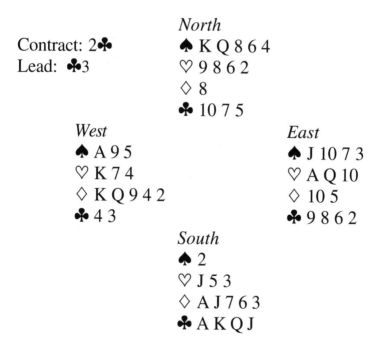

North
Contract: 2♣ ♠ K Q 8 6 4
Lead: ♣3 ♡ 9 8 6 2
 ◇ 8
 ♣ 10 7 5

West *East*
♠ A 9 5 ♠ J 10 7 3
♡ K 7 4 ♡ A Q 10
◇ K Q 9 4 2 ◇ 10 5
♣ 4 3 ♣ 9 8 6 2

South
♠ 2
♡ J 5 3
◇ A J 7 6 3
♣ A K Q J

Worth noting: West's excellent trump lead. When
declarer's 2nd suit becomes trumps, an opening lead
of a trump is often best for the defense. That theme
will prevail on the hands that follow in this chapter.
In fact, it's fair to say: **When you're on lead against
a partscore in a suit contract, seriously consider a
trump lead.**

Scrambling Seven Tricks

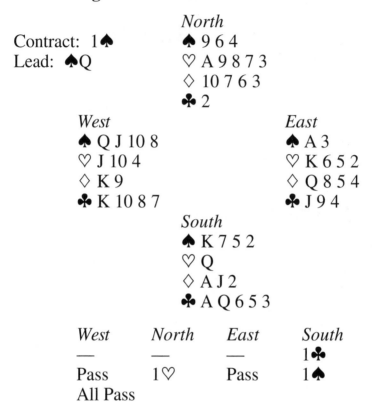

Contract: 1♠
Lead: ♠Q

North
♠ 9 6 4
♡ A 9 8 7 3
◇ 10 7 6 3
♣ 2

West
♠ Q J 10 8
♡ J 10 4
◇ K 9
♣ K 10 8 7

East
♠ A 3
♡ K 6 5 2
◇ Q 8 5 4
♣ J 9 4

South
♠ K 7 5 2
♡ Q
◇ A J 2
♣ A Q 6 5 3

West	North	East	South
—	—	—	1♣
Pass	1♡	Pass	1♠
All Pass			

South had 16 HCP, but, with North's sub-minimum, even 7 tricks were not guaranteed. East won the trump lead with his ♠A, and fired back a trump to South's ♠K. Declarer needed 3 ruffs to go along with his 4 top tricks. Before ruffing a club with dummy's last trump, he set his sights on *two* heart ruffs.

South led the ♡Q to the ace, and then ruffed a heart. He cashed the ♣A and ruffed a club. Declarer scored his sixth trick by ruffing another heart with his last trump, and the ◇A provided the seventh trick.

A Tip You Can Take to the Bank

"When in doubt in a suit contract, declarer should develop his own longest side suit."

Early in my bridge career, I was fortunate enough to read this tip in a bridge column. I can honestly say that, in a lifetime of playing bridge, it is the most helpful tip on declarer play that I've ever encountered!

On the following hand, can you make eight tricks after West's annoying trump lead?

Contract: 2♢
Lead: ♢5

North
♠ J 7 6 4 3
♡ Q
♢ Q J 7
♣ J 6 5 3

South
♠ Q
♡ 10 6 5 4 3
♢ A K 10 9 2
♣ A 9

You have 5 trump winners and the ♣A, so you need 2 additional tricks. One heart ruff will be easy, but West's trump lead prevents you from ruffing 2 hearts. Setting up your emaciated heart suit will not be easy. However...

You win the ◇J and lead the ♡Q. East wins the ♡A, and returns a trump. You win in your hand, and ruff a heart. You then cross back to your hand with the ♣A, draw the last trump, and lead a third round of hearts.

West wins, and cashes the ♣K. He leads a spade to East's ♠A, and East returns a spade. You ruff, but still have one trump remaining. You then lead the fourth round of hearts. West can win the trick, but your last two cards are a trump and the 13th heart. Making 2◇ – well done.

Here is the entire deal:

	North	
Contract: 2◇	♠ J 7 6 4 3	
Lead: ◇5	♡ Q	
	◇ Q J 7	
	♣ J 6 5 3	

West		East
♠ K 10 8 5		♠ A 9 2
♡ K J 9 2		♡ A 8 7
◇ 8 6 5		◇ 4 3
♣ K 10		♣ Q 8 7 4 2

	South	
	♠ Q	
	♡ 10 6 5 4 3	
	◇ A K 10 9 2	
	♣ A 9	

Creating an Extra Trump Trick Out of Thin Air

Contract: 3♠
Lead: ♠2

North
♠ 7 4
♡ A 5
◇ A J 9 7 2
♣ A K 6 4

South (You)
♠ A J 10 9 8
♡ 7 6 4 3 2
◇ 4
♣ 7 5

West	North	East	South
Pass	1◇	Pass	1♠
Pass	2♣	Pass	2♠
Pass	3♠	All Pass	

After a difficult (but sensible) auction, you arrive in a precarious partscore. At trick one, East follows with the ♠Q and you win the ace. You have 8 winners: 2 clubs, 1 diamond, 1 heart and 4 spades.

You'd love to ruff a heart, but if you lead hearts, E-W will win and pull dummy's last trump. As for setting up your 5th heart, unless both majors divide 3-3, which is *very* unlikely, that won't work.

After the trump lead, it looks bad. Or does it?

The solution is to ruff a lot of minors in your hand, and score a fifth trump winner.

Trick 2: Lead a diamond to dummy's ace.

Trick 3: Ruff a diamond with your ♠8.

Trick 4: Lead a club to dummy's ace.

Trick 5: Ruff a diamond with your ♠9.

Trick 6: Lead a club to dummy's king.

Trick 7: Ruff a club with your ♠10.

Trick 8: Lead a heart to dummy's ace.

Trick 9: Ruff either minor with your ♠J.
West will overruff with his king.
No problem; dummy's ♠7 is your 9th trick.

Here is the entire deal:

	North	
Contract: 3♠	♠ 7 4	
Lead: ♠2	♡ A 5	
	◇ A J 9 7 2	
	♣ A K 6 4	

West	*East*
♠ K 6 2	♠ Q 5 3
♡ Q 10 9 8	♡ K J
◇ Q 8 5	◇ K 10 6 3
♣ J 8 3	♣ Q 10 9 2

	South
	♠ A J 10 9 8
	♡ 7 6 4 3 2
	◇ 4
	♣ 7 5

Chapter 13

Setting Up
Your Long Suit

Enjoying Your 6-Card Majors

	North
Contract: 4♡	♠ A J 9 7 4 3
Lead: ♡2	♡ A 5
	◇ 2
	♣ A K 9 8

South
♠ 2
♡ K Q J 10 9 7
◇ J 9 6 3
♣ 5 2

West	*North*	*East*	*South*
Pass	1♠	Pass	1NT
Pass	2♣	Pass	2♡
Pass	4♡	All Pass	

North's flexible 2♣ bid was the key to reaching the excellent 4♡ contract. When South ignored both of North's suits and introduced his own, he needed a *long* suit – at least six cards. North knew that 4♡ had to have play based on his trump support, singleton, and 4 quick tricks.

Question 1: You have nine obvious winners. What is your plan for a tenth trick?

Question 2: Where should you win the first trick?

Question 3: How will you continue?

Question 1: You have nine obvious winners. What is your plan for a tenth trick?

Answer: After the trump lead, you lack the timing to get a diamond ruff. Therefore, you need to set up dummy's spade suit.

Question 2: Where should you win the first trick?

Answer: In your own hand. This is definitely not the time to "use up the honor from the short side first." Every one of dummy's entries will be useful *later on.*

Question 3: How will you continue?

Answer: After you win the ♡2 in your hand, lead a spade to dummy's ace. Ruff a spade, and lead a trump to dummy's ♡A. Once both opponents follow to two rounds of spades and two rounds of trumps, you are guaranteed to win at least 11 tricks.

You then lead a third round of spades as East shows out. No problem. You ruff and draw the last trump. You still have one trump remaining in your hand. Lead a club to dummy's ace, and ruff out West's ♠K. Dummy's two remaining spades are now good.

Lead a club to dummy's ♣K and cash the two spade tricks. You have won the first 11 tricks, so concede the last two tricks – making five.

Here is the entire deal:

Contract: 4♡ *North*
Lead: ♡2 ♠ A J 9 7 4 3
 ♡ A 5
 ♢ 2
 ♣ A K 9 8

West *East*
♠ K 10 8 5 ♠ Q 6
♡ 6 4 2 ♡ 8 3
♢ A 10 8 ♢ K Q 7 5 4
♣ 7 4 3 ♣ Q J 10 6

 South
 ♠ 2
 ♡ K Q J 10 9 7
 ♢ J 9 6 3
 ♣ 5 2

West	*North*	*East*	*South*
Pass	1♠	Pass	1NT
Pass	2♣	Pass	2♡
Pass	4♡	All Pass	

I Never Met a Five-Card Suit I Didn't Like

Too often, the average declarer has a short-sighted point of view. All he notices are his honor cards. He begins the play of a hand by grabbing the obvious winners, then tries a finesse or two. When the smoke clears, all he has won is what he had coming – no more, no less.

A better player has a totally different perspective. He is not in any hurry. He doesn't care whether or not he wins tricks at the beginning of the hand, as long as he ends up with the desired total. He will frequently **"lose his losers early."**

Winning tricks with small cards is one of the traits that separates a good bridge player from one who simply "pushes cards." A good player appreciates long suits and their ability to produce extra tricks. Anyone can win tricks with aces and kings; it's far more satisfying to win tricks with twos and threes.

On the following deal, nobody would be impressed with the quality of dummy's diamonds. But, on many hands, length is more important than strength.

The question is: can you demonstrate your great appreciation for diamonds, despite the fact that they don't sparkle brightly?

	North
Contract: 4♠	♠ A 10
Lead: ♣Q	♡ A 10 4
	◇ 6 5 4 3 2
	♣ A 6 5

South
♠ K Q J 9 8 6
♡ J 6 3
◇ Q
♣ K 3 2

West	*North*	*East*	*South*
—	1◇	Pass	1♠
Pass	1NT	Pass	4♠
All Pass			

You have 4 possible losers: 1 diamond, 1 club, and 2 heart tricks. 3NT would have been easier, but, if you play your cards right and truly believe that, sometimes, "diamonds are a bridge player's best friend," you will be able to bring home 10 tricks. Take a moment to plan your line of play and see if you can succeed as well as the actual declarer did.

By persisting with dummy's longest suit, declarer demonstrated how good players make something out of nothing.

Declarer hoped for normal splits in diamonds and spades. This represented a better chance than trying to create an extra heart trick.

Because it was critical to preserve entries to dummy, declarer won the opening club lead in his hand. At trick two he led the ♢Q. West won with his ace and continued the club attack; no other play would have affected the outcome. After winning the ♣A, South ruffed a diamond, leaving the opponents with a total of three cards in that suit.

Declarer played a spade to dummy's 10 – *"Good card, partner!"* He then ruffed another diamond with a high trump. When everyone followed, he knew that diamonds were dividing 4-3. A spade was led to dummy's ace, and the normal 3-2 trump split was noted. It was then easy to trump dummy's fourth diamond, felling East's king, and draw the last trump.

After three diamond ruffs and three rounds of trumps, declarer had run out of trumps. However, with dummy's ♡A and ♢6 delivering tricks 9 and 10, South was delighted to score up his game.

Here is the entire deal:

		North	
Contract: 4♠		♠ A 10	
Lead: ♣Q		♡ A 10 4	
		◊ 6 5 4 3 2	
		♣ A 6 5	
West			*East*
♠ 7 5 3			♠ 4 2
♡ K 9 5			♡ Q 8 7 2
◊ A J 8			◊ K 10 9 7
♣ Q J 10 9			♣ 8 7 4
		South	
		♠ K Q J 9 8 6	
		♡ J 6 3	
		◊ Q	
		♣ K 3 2	

West	*North*	*East*	*South*
—	1◊	Pass	1♠
Pass	1NT	Pass	4♠
All Pass			

Setting Up *Your* 6-Bagger

Contract: 4♠ *North*
Lead: ♡K ♠ A 10 8
 ♡ A 6 4
 ◇ A 9 7 5 4 3
 ♣ 6

 South
 ♠ K 5 4 3 2
 ♡ 5
 ◇ 6
 ♣ A 8 7 5 3 2

West	*North*	*East*	*South* (you)
Pass	1◇	Pass	1♠
Pass	2♠	Pass	4♠
All Pass			

A typical North player would have rebid 2◇, ending
the auction. Despite your great shape, with a puny
7 HCP and a misfit for diamonds, you would have
been forced to call it a day.

Fortunately, *this* North was a charter member of the
"I support partner's major whenever possible" club.
He liked his spades well enough to raise to 2♠.
This made everything easy. Having located a fit,
you reevaluated your very distributional hand,
and lost no time jumping to 4♠.

You win the opening heart lead with dummy's ace – that was easy. You have five tricks in high cards. However, the best approach to win five additional tricks is far from clear.

The spotlight is on *you.* Take a good look at the N-S cards, and make your decision before reading on. Here are the four possible lines of play:

1. Draw trumps now.

2. Crossruff.

3. Set up dummy's diamonds.

4. Set up your clubs.

I hope that you would not begin by drawing trumps. Some players might try to crossruff dummy's red suits and your clubs. However, because of your terrible spade spots and your combined length in both minor suits, you are likely to get overruffed at some point.

You might consider setting up dummy's diamonds. Unfortunately, once the ♡A was knocked out, even if diamonds divide 3-3, you lack the entries to get back to the board and eventually run diamonds.

The correct line of play is to set up *your* club suit. As stated earlier: **when in doubt in a suit contract, declarer should develop his own longest side suit.** What are the entries to your hand? Your trumps!

Lead a club to your ace and ruff a club. Now cash the ace and king of spades. Once both opponents follow, you are home free – as long as you persist with clubs. Even though the defender's clubs don't divide 3-3, you can't be stopped from eventually establishing two winners in your long suit.

Regardless of what West does after winning his ♣10, you will lose only two club tricks and the ♠J.

Here is the entire deal:

North

Contract: 4♠ ♠ A 10 8
Lead: ♡K ♡ A 6 4
 ◇ A 9 7 5 4 3
 ♣ 6

West *East*
♠ J 9 6 ♠ Q 7
♡ K Q J 9 ♡ 10 8 7 3 2
◇ Q 10 ◇ K J 8 2
♣ Q 10 9 4 ♣ K J

 South
 ♠ K 5 4 3 2
 ♡ 5
 ◇ 6
 ♣ A 8 7 5 3 2

Chapter 14

Making the Most of Your Entries

Some Hands Get Better With Age

As South you pick up:

♠ 7 ♡ 6 4 3 2 ◇ A Q 3 2 ♣ A Q J 5

The auction proceeds:

West	North	East	South
—	—	1NT	Pass
2♡*	Dbl	2♠	???

2♡* = Jacoby Transfer

You recognize partner's double as lead-directing, promising length and strength in hearts. As expected, opener then bids 2♠.

Based on the early auction, do you believe your nice hand merits taking any action?

Definitely. **Supporting partner when you like his major suit is what bridge is all about.**

If you bid 3♡, you are on the right track. However, I believe that the standout action is to jump to 4♡. Your partner promised at least five good hearts. Your ace-queens are well-placed behind the notrump opener, and your singleton spade guarantees that you won't lose any more than one trick in that suit.

Your jump to 4♡ ends the auction.

Unfortunately (for you), West makes the indicated lead of a trump. When your opponent opens 1NT and your side finds a fit and obtains the contract, you must have a lot of distribution. **Therefore, on these auctions, the opponents should lead trumps.**

North tables a hand with which very few players would have doubled.

♠ A 5 4 ♡ Q 10 9 8 7 ◇ 9 4 ♣ 7 4 2

The double was very frisky, but I confess that I would have made the same call. The importance of helping partner find the best lead cannot be overemphasized.

	North
Contract: 4♡	♠ A 5 4
Lead: ♡5	♡ Q 10 9 8 7
	◇ 9 4
	♣ 7 4 2
	South (You)
	♠ 7
	♡ 6 4 3 2
	◇ A Q 3 2
	♣ A Q J 5

West	North	East	South
—	—	1NT	P
2♡*	Dbl	2♠	4♡
All pass			

2♡* = Jacoby Transfer

Anyway, on to the play. You certainly have some work
to do. You try the ♡10, but East wins with the jack.
He then cashes the ♡AK. West, who started with a
singleton trump, encourages in spades. East then
shifts to the ♠2, and you win dummy's ace.

Count your winners. Dummy still has two trumps,
but you have only one trump in your hand, so you can
ruff only one spade. That's three tricks. You already
won the ♠A, so you need to win six tricks with your
minor-suit cards. Because there is no hope of winning
more than two diamond tricks, you'll need to win all
four of your clubs in order to bring home the contract.

Time for a finesse. The good news is that you are
almost certain that it will win. N-S have a total of
19 HCP, so E-W have 21 HCP, and East has at least 15
of them. West must have some spade honors, so there
is not much room left in his hand for an outside king.
Obviously, if he has one, 4♡ can't be made.

The bad news is that you have *many* finesses to take,
but not many entries to dummy.

Question: Which finesse do you take *now*?

Answer: Although the clubs are stronger and will
produce more tricks, you must take the diamond
finesse first.

Why is that? If you did take a successful club finesse, what would you do for an encore? You'd be stuck in your hand – the *last* place you want to be.

Here is a summary of the correct line of play:

Tricks 1-3: The defense pulled three rounds of trumps.

Trick 4: You won the ♠A in dummy.

Trick 5: Finesse the ◇Q.

Trick 6: Cash the ◇A.

Trick 7: Ruff a diamond to get to the board.

Trick 8: Finesse the ♣Q.

Trick 9: Ruff a diamond with dummy's last trump to get back to dummy.

Trick 10: Finesse the ♣J.

Trick 11: Cash the ♣A. Both follow. YES!!

Trick 12: Cash the ♣5.

Trick 13: Win the last trick with your ♡6.

By the way: If you have never bid after partner's lead-directing double, I hope that this hand provides food for thought. If you regard a lead-directing double as indicating a suit worth overcalling, then bidding the suit that partner promised is just one more example of "support with support."

Here is the entire deal:

	North	
Contract: 4♡	♠ A 5 4	
Lead: ♡5	♡ Q 10 9 8 7	
	◇ 9 4	
	♣ 7 4 2	

West		East
♠ K Q 10 8 6		♠ J 9 3 2
♡ 5		♡ A K J
◇ 10 8 6 5		◇ K J 7
♣ 10 8 6		♣ K 9 3

	South	
	♠ 7	
	♡ 6 4 3 2	
	◇ A Q 3 2	
	♣ A Q J 5	

West	North	East	South
—	—	1NT	P
2♡*	Dbl	2♠	4♡
All pass			

2♡* = Jacoby Transfer

Maneuvering Trump Entries Like a Virtuoso

Drawing trumps with a long, strong suit is not
difficult, but neither should it be considered routine.

By exercising a bit of care and effort, you can maintain
great flexibility while pulling trumps.

Suppose your trump suit consists of the following –
which is nothing to sneeze at.

North
Q J 5 3

South (You)
A K 10 8 6 2

Assume that, as expected, trumps divide 2-1.
If you play the AK while playing low from dummy,
you will find yourself with:

North
Q J

South
10 8 6 2

Very inflexible; you no longer have any entries to the
South hand. This could prove to be a huge problem
later on.

If, instead, you cash the QJ while playing low from
your hand, the result will be:

North
5 3

South
A K 10 8

Equally inflexible; now you don't have any entries to
the North hand.

Start again. Take the ace and lead the six to the queen
(among many equivalent solutions). You now have:

North
J 5

South
K 10 8 2

This leaves two entries to each hand. You lose nothing
with this approach, and, if you need the entries later,
it will make all the difference in the world.

I hope you agree that this approach is not only
important, but can be fun. You can easily practice
on your own. All you need is one suit of 13 cards.
Arrange this suit as if there were four players,
and play around with various layouts of the cards
until you become a "master of entries."

More Entries Than Meet the Eye

"Is that all you have?" exclaimed South, when North tabled his dummy. If only declarer had realized how useful dummy's hand could have been.

	North	
Contract: 4♡	♠ 8 7 5 4	
Lead: ◇K	♡ 10 8 6	
	◇ 9 6 5	
	♣ 7 5 4	

West		East
♠ 10 3		♠ K 9 6 2
♡ 3		♡ A 5 4
◇ K Q 8 7 3		◇ A J 4 2
♣ J 9 6 3 2		♣ Q 10

	South	
	♠ A Q J	
	♡ K Q J 9 7 2	
	◇ 10	
	♣ A K 8	

West	North	East	South
—	—	1◇	Dbl
3◇	Pass	Pass	4♡
All Pass			

South needed very little to make 4♡, so he jumped to game at his second turn after West crowded the auction with a preemptive jump raise.

West led the ◇K and continued with another diamond. Declarer ruffed with the ♡2, but could no longer make the hand! When he led the ♡K, East knew enough to play low; after all, what was the hurry? It was then impossible for declarer to enter dummy in trumps more than once, and one successful spade finesse was not enough.

Eventually, declarer lost a trick to the ♠K as well as his inevitable losers in diamonds, hearts and clubs. South was unlucky to be playing against a capable defender; however...

Declarer should have trumped the second round of diamonds with one of his honors. **Trumping with honors is not showing off – sometimes it is the only way to preserve entries.** If South had trumped high, he could have forced 2 entries to dummy, as follows:

First, he would lead the ♡2 to dummy's six. For now, let's assume that East wins his ace. At this point, the trump position would be:

```
                    North
                    ♡ 10 8
      West                          East
      ♡ —                           ♡ 5 4
                    South
                    ♡ K Q 9 7
```

Suppose East returns a 3rd round of diamonds, which is as good as anything. Once again, declarer is careful to ruff with a trump honor, and is still in control. He then leads the ♡7 to the 8 and takes the spade finesse thru the opening bidder. When that wins, he repeats the maneuver; ♡9 to the 10 for a second winning spade finesse.

If East had chosen to duck dummy's ♡6 on the first round of trumps, it would not have helped the defense. After winning the trick on the board, declarer would be well-placed to take an immediate spade finesse. The trump position would then be:

 North
 ♡ 10 8
 West *East*
 ♡ — ♡ A 5
 South
 ♡ K Q 9 7

This position is virtually the same as before, except that East still has the ace of trumps. No problem. Declarer will lead the ♡7 to the 8. Once again, the defense is helpless. Suppose East wins his ace and persists with diamonds. South will trump with an honor, and lead the ♡9 to dummy's 10 for a second spade finesse.

When dummy came down, South should have said: "Thank you, partner – what nice trumps you have."

{Deal repeated for convenience}

		North	
Contract: 4♡		♠ 8 7 5 4	
Lead: ◇K		♡ 10 8 6	
		◇ 9 6 5	
		♣ 7 5 4	
West			*East*
♠ 10 3			♠ K 9 6 2
♡ 3			♡ A 5 4
◇ K Q 8 7 3			◇ A J 4 2
♣ J 9 6 3 2			♣ Q 10
		South	
		♠ A Q J	
		♡ K Q J 9 7 2	
		◇ 10	
		♣ A K 8	

West	*North*	*East*	*South*
—	—	1◇	Dbl
3◇	Pass	Pass	4♡
All Pass			

This Duck is Delicious

When declarer has an inevitable loser, he should usually lose it sooner rather than later. This variation of the holdup play is referred to as a "duck," and its purpose is to preserve entries.

North

Contract: 6♠
Lead: ◇J

♠ 6 4
♡ A 9 4
◇ Q 3
♣ A 9 7 6 4 3

South
♠ A K Q J 9 3 2
♡ K 7 2
◇ A
♣ 8 5

You have 11 sure winners, and as long as clubs divide 3-2, you can develop a 12th – as long as you make the most of dummy's two entries. Win the diamond lead, draw trumps and lose (duck) a club. Win any return in your hand and lead a club to dummy's ace.

Now, establish dummy's suit by ruffing out the opponent's one remaining club. Cross to dummy's ♡A, discard your heart loser on a club winner, and score up your slam.

Chapter 15

Don't Rely on
Good Splits

Laying the Groundwork

Contract: 4♡
Lead: ♣Q

North
♠ 10 7 5 4
♡ 3
♢ A 8 7 5 4
♣ A 8 6

South
♠ A 9 8
♡ A K Q J 9 4 2
♢ 9 6
♣ 2

West	*North*	*East*	*South*
—	—	—	1♡
Pass	1♠	Pass	4♡
All Pass			

You needed very little from partner, so you took the bull by the horns and jumped to game. If partner had a good hand and chose to bid on, that would have been fine with you.

You win the first trick with dummy's ♣A.

Question 1: Can anything go wrong in this seemingly ice-cold contract?

Question 2: What do you lead at trick 2?

Question 1: Can anything go wrong in this seemingly ice-cold contract?

Answer: Yes. If one opponent has all 5 trumps, you could lose 2 spade tricks, 1 heart and 1 diamond.

Question 2: What do you lead at trick 2?

Answer: You should lead a club and ruff it. If either player has all of the missing trumps, you need to win tricks with your small trumps whenever possible. This is a perfect opportunity to win your ♡2.

At trick 3, you lay down the ♡A. Sure enough, West shows out. East (in front of you) has the missing trumps, which beats the heck out of finding all five trumps with West (behind you).

You are actually sitting pretty. Cash the ♠A and cross to dummy with the ◇A. Lead dummy's ♣8 and ruff with your ♡4. You have now won six tricks.

The stage is now set. Exit with a spade or a diamond. The defenders are welcome to take their three tricks in those suits.

At this point, the only relevant suit is hearts. Here are the remaining trumps:

East
♡ 10 8 7 6

South
♡ K Q J 9

Regardless of the defense, you can't be prevented
from winning all four of your trumps and making 4♡.
Winning your RHO's trumps without being able to
finesse is called a Trump Coup.

Here is the entire deal:

Contract: 4♡
Lead: ♣Q

North
♠ 10 7 5 4
♡ 3
♢ A 8 7 5 4
♣ A 8 6

West
♠ K J 6 2
♡ —
♢ J 10 3 2
♣ Q J 10 5 3

East
♠ Q 3
♡ 10 8 7 6 5
♢ K Q
♣ K 9 7 4

South
♠ A 9 8
♡ A K Q J 9 4 2
♢ 9 6
♣ 2

West	North	East	South
—	—	—	1♡
Pass	1♠	Pass	4♡
All Pass			

Handle with Care

Leading from weakness toward strength can be crucial even if there is no finesse.

If you're afraid that a defender might be void in a particular suit, don't give him the chance to ruff a WINNER.

	North
Contract: 4♠	♠ A J 3
Lead: ♡A	♡ 8 6 2
	◇ K 8 7 2
	♣ 7 6 4

South
♠ K Q 10 8 7 5
♡ J 10
◇ —
♣ A K 8 5 3

West	*North*	*East*	*South*
—	—	—	1♠
Dbl	2♠	Pass	4♠
All Pass			

West led hearts, and continued the suit. South ruffed the third round and focused on clubs. West had promised length with his takeout double. If West had only 3 clubs, the suit was splitting and all was well. If West had all 5, the hand could not be made. Therefore, South focused on a 4-1 club split.

Declarer cashed the ♣A and led a spade to the ace. He then led a club from dummy. East had no good options. If he ruffed, declarer would win any return, pull East's last trump, cash the ♣K and ruff a club. If East chose not to ruff, declarer would win the ♣K, concede a club, and later ruff a club with the ♠J.

Here is the entire deal:

	North	
Contract: 4♠	♠ A J 3	
Lead: ♡A	♡ 8 6 2	
	◇ K 8 7 2	
	♣ 7 6 4	
West		*East*
♠ 2		♠ 9 6 4
♡ A K 9 4		♡ Q 7 5 3
◇ A Q 10 9		◇ J 6 5 4 3
♣ Q 10 9 2		♣ J
	South	
	♠ K Q 10 8 7 5	
	♡ J 10	
	◇ —	
	♣ A K 8 5 3	

Develop, Don't Grab

	North	
Contract: 1NT	♠ 6 5 4	
Lead: ♠3	♡ J 7 4 3	
	◇ K Q 5 4	
	♣ 10 4	

West	*East*
♠ A K 10 3 2	♠ J 9
♡ Q 8 5 2	♡ 10 6
◇ 9	◇ J 10 8 3
♣ 9 6 2	♣ A K 8 7 3

	South
	♠ Q 8 7
	♡ A K 9
	◇ A 7 6 2
	♣ Q J 5

West	North	East	South
—	Pass	Pass	1NT
All Pass			

At trick one, South was delighted to capture East's ♠J with the queen. He had six obvious tricks: two hearts, three diamonds and one spade. He knew that it is *usually* correct to work on his side's longest combined suit in a notrump contract, so he turned his attention to diamonds.

South knew that a normal 3-2 diamond split would guarantee his seventh trick. Unfortunately, diamonds did *not* divide normally. After grabbing the ◇AK, the diamond length was useless.

Declarer then turned his attention to hearts – his second-longest suit. He cashed the ace and king, and was pleased to see East's 10. At this point, South had won the first 5 tricks. He then led the ♡9 to West's queen, setting up dummy's jack. As soon as South regained the lead, the ◇Q and ♡J would provide declarer's sixth and seventh tricks.

However, it was too late. Once the declarer set up West's ♡Q, the defense had seven winners. West ran spades, while East encouraged in clubs. The defense took 4 spade tricks, 1 heart and 2 clubs for down one.

Declarer erred at trick two. With dummy's lovely ♣10 solidifying South's ♣QJ5, developing one club winner was a sure thing. If declarer had immediately attacked clubs, the defenders could never have taken more than 2 clubs and 4 spade tricks.

Many players merrily take their sure winners, hoping something good will happen. If you're content to play like the masses, keep on grabbing. However, if you want more (tricks) out of life, keep this in mind: "Anyone can grab obvious winners; good players prefer to *develop* tricks that didn't previously exist."

Going with the Odds

When missing six cards in a suit, a 3-3 split is against the odds. Don't count on it.

Contract: 4♠
Lead: ♡J

North
♠ 10 6
♡ 7 5 4 2
♦ 6 5
♣ K 9 7 5 2

South
♠ A K 7 4 3
♡ 9
♦ A K Q J 10
♣ A 4

The defense began with two rounds of hearts. After ruffing the second, South cashed his ace and king of spades. He then had two small trumps. If the defenders' two remaining trumps divided 1-1, he could play a third round and make an overtrick. But, even if he were playing matchpoint duplicate, that would be crazy. If one defender had both trumps, playing a third round would allow that defender to draw South's last trump and run hearts.

Instead, declarer simply ran diamonds and conceded two trump tricks, keeping control of the hand and guaranteeing 10 tricks.

Chapter 16

Life is Pleasing When You Start Squeezing

Not For Experts Only

"A well-played bridge hand has as much power to thrill and to satisfy as a Beethoven symphony."
 Hugh Kelsey, prolific Scottish bridge writer

For many players, the most fascinating and exciting of the so-called advanced plays is the squeeze. I'll never forget one of my favorite memories as a teacher. It occurred many years ago when my phone rang around 12:30 a.m. To my great surprise, it was one of my students.

"I hope I'm not waking you, Marty, but I just *had* to call," she said.

"No problem, Kitty. Are you okay?" I replied.

"Oh yes, I'm wonderful," she said. "I was playing bridge this evening, and I just executed my first squeeze. I haven't been so excited since the birth of my first child!"

Unfortunately, the topic of squeezes has acquired an unwarranted mystique and is regarded as being too difficult for the average player. There are some very complex squeezes, including ones in which both defenders are squeezed, but the truth is that **the basic squeeze can be executed by anyone**. The best way to approach this topic is with questions and answers. Here we go:

1. When should a squeeze be attempted?

When there is no other way to get rid of a loser.
The outlook is bleak, so you have nothing to lose by
attempting a squeeze.

Opportunities for squeezes occur quite often. Suit
contracts and notrump are both fair game. You should
try for a squeeze whether the hoped-for extra trick
fulfills the contract or produces an overtrick.

2. What do you need to do?

Take *all* your winners in the irrelevant suits, and
hope. That's basically it!

3. How do you distinguish between the relevant suit and the irrelevant one(s)?

The irrelevant suits are those in which declarer has
no chance of creating an extra winner. One example
is a suit where the enemy has become void, such as
trumps. Another example is a suit such as A2 opposite
dummy's K3. If either of you held a third card, such
as A2 opposite K43, **it would become a relevant suit**.
If neither opponent kept three (or more) cards in that
suit, you would be able to win a third trick.

The extra card is called a threat card (or menace)
because its very existence threatens the opposition.
One opponent must keep three cards in that suit to
prevent your third card from becoming a winner.

4. What else must declarer do?

A. Keep the lines of communication open between his hand and the dummy. It does not help you if an opponent's discard establishes a winner that you can't get to.

B. Keep an eye on the opponents' discards. Fortunately, on most basic squeezes, you only need to keep track of what is being discarded in the relevant suit(s).

5. What are you hoping for?

If one (or both) defenders threw away the wrong cards, it would not bother you at all. Discarding is often difficult, tedious, and annoying. The more discards you squeeze out of your opponents, the greater the chance for a mistake. If you make the hand because of a discarding error, it is referred to as a *pseudo-squeeze*.

However, you don't need to depend on an enemy error to gain a trick when you attempt a squeeze. When you cash your last winner in the irrelevant suit(s), you are hoping that one opponent has two suits to guard. He will then be forced to discard a winner from one of the relevant suits. These are *legitimate squeezes* and can operate even against perfect defense.

6. How often do squeezes occur?

More often than you think. I can't tell you how many times I have been aware of an upcoming squeeze while watching as dummy – if only declarer would cash his last winner.

In addition, the potential for a pseudo-squeeze occurs on every deal. You should not get into the habit of saying: "I'll give you a trick." Instead, play out the hand and give your opponents a chance to make the wrong discard.

It is even possible for the defending side to execute a squeeze on declarer or dummy. There are also occasions when one defender squeezes his partner. By the way, squeezing your partner is definitely frowned upon – at least at the bridge table.

7. What else should you know in order to execute a squeeze?

Squeezes function most efficiently when declarer has already lost *all* of the losers he can afford to lose. So, in order to set up a squeeze, on some hands, declarer should make sure to "lose his losers early." When you're discussing squeezes, this technique is referred to as **rectifying the count.**

8. Last but not least. Remember:

- Deciding what to discard is not easy.
 Get into the habit of making the enemy sweat.

- Bridge is not like pinochle; you don't receive a
 bonus for winning the last trick. Therefore,
 instead of holding onto a winner – cash it.

- Never give up. Even if you have a sure loser,
 give yourself a chance to avoid it.

Are you ready to start squeezing?

	North
Contract: 7NT	♠ K 7 4
Lead: ♡ 10	♡ K Q
	◊ K Q 7 4
	♣ A K Q 10

South
♠ A Q 6 2
♡ A J
◊ A 6 5
♣ J 9 7 5

Sadly, your 4 heart honors will take only 2 tricks,
so you have just 12 winners. If either spades or
diamonds divide 3-3, you are all set. However...

Question: After winning the heart lead, what suits
will you play at tricks 2-6?

Answer: Cash your winners in the *irrelevant* suits, clubs and hearts. On the actual deal, East held:

♠ J 10 9 3 ♡ 7 4 3 2 ◇ J 10 9 3 ♣ 3

You won the heart lead on the board and ran clubs. East followed to the first club, and discarded hearts on the next three rounds. With South to lead, here is the position:

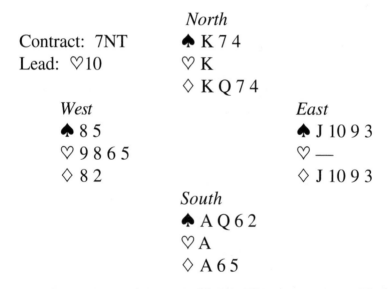

Contract: 7NT
Lead: ♡10

North
♠ K 7 4
♡ K
◇ K Q 7 4

West
♠ 8 5
♡ 9 8 6 5
◇ 8 2

East
♠ J 10 9 3
♡ —
◇ J 10 9 3

South
♠ A Q 6 2
♡ A
◇ A 6 5

When you cash the ♡A, East is squeezed, forced to unguard one of his stoppers in spades or diamonds. You'll take note of the discard and will then be able to win a fourth trick in that suit, even though it did not divide 3-3.

Now take a look at the very similar deal on the next page.

North

Contract: 6NT
Lead: ♥10

♠ K 7 4
♡ J 4
◇ K Q 7 4
♣ A K Q 10

South

♠ A Q 6 2
♡ A 2
◇ A 6 5
♣ J 9 7 5

West	North	East	South
—	—	—	1NT
Pass	6NT	All Pass	

You can afford to lose one trick, so duck the opening heart lead to rectify the count. Now it's déja vu all over again. Win the heart continuation with the ace, cash your club winners, and hope for the best.

If either spades or diamonds are 3-3, all is well. OR, if a defender has 4+ diamonds as well as 4+ spades, he will eventually be squeezed. OR, if a defender with 4 spades or 4 diamonds mistakenly discards one, you'll make 6NT courtesy of a pseudo-squeeze.

If none of the above materializes, you're very unlucky and will go down. But, with your good squeeze technique, I like your chances.

South Has the Last Laugh

On this deal, observe how the noose eventually tightens around West's neck. There was absolutely nothing that he (or East) could have done about it.

	North	
Contract: 4♥	♠ 5 4 3 2	
Lead: ♠A	♥ Q 10 8 5	
	◇ J 5	
	♣ A K 2	

West		East
♠ A K 10 7		♠ 9 8
♥ 9		♥ 4 3 2
◇ Q 9 3		◇ 10 8 7 6 4 2
♣ Q 10 8 6 4		♣ J 3

	South
	♠ Q J 6
	♥ A K J 7 6
	◇ A K
	♣ 9 7 5

West	North	East	South
—	—	—	1♥
Dbl	2NT*	Pass	4♥
All Pass			

2NT* = Jordan, promising a limit raise (or better) in support of hearts.

West led the ♠A and East signaled with the nine. West naturally continued with the king, followed by a third spade for East to ruff. East then led back his fourth-best diamond.

Declarer needed the rest of the tricks, but he was looking at an inevitable club loser. Dummy's ♠5 was not a winner, because West still had a higher spade. However, South did believe in squeezes, so the thought of giving up never occurred to him.

Declarer won East's ♢6 with his ace and drew two rounds of trumps. South then cashed his ♢K, the winner in the *irrelevant* suit, and continued trumps.

He knew not to play clubs, a very *relevant* suit. It was also critical to keep at least one entry to dummy to maintain communication between the two hands.

Declarer made sure to win the fourth trump in his hand in order to lead his last trump. He had no idea whether a squeeze would operate on the deal. The good news was that he did not need to count or even notice *all* of the opponents' discards. All he needed to do was keep his eyes open, just in case West was careless and discarded his ♠10.

Here was the position as declarer led his last trump:

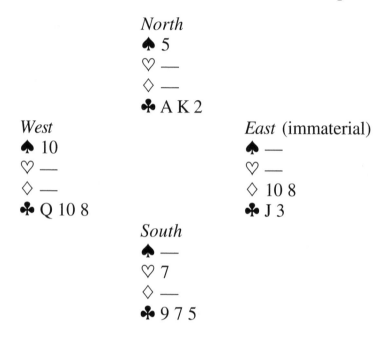

North
♠ 5
♡ —
♢ —
♣ A K 2

West
♠ 10
♡ —
♢ —
♣ Q 10 8

East (immaterial)
♠ —
♡ —
♢ 10 8
♣ J 3

South
♠ —
♡ 7
♢ —
♣ 9 7 5

When the ♡7 was led, West was squeezed because East was unable to guard clubs. West had to keep the ♠10, so he reluctantly discarded the ♣8. Declarer discarded dummy's ♠5; there was no point in keeping it once West kept his higher spade.

Declarer then led clubs and hoped for the best. Because West had five clubs, South's prayers were answered. Of course, if West had discarded his spade, South would have won a trick with North's ♠5.

West could have done nothing in the endgame. When you play well, and the cards cooperate, even the best players in the world are at your mercy.

Bergenisms

Chapter 1 - Getting Off on the Right Foot

Page #

13. Before playing at trick one:
 - count winners and/or losers;
 - think about your entries;
 - and, last but certainly not least,
 do not proceed without a plan.

14. When you have a choice of where to win
 a trick, think carefully about where you'll
 need to be later on.

15. When you are setting up a suit, "use up
 the honor(s) from the short side first."

16. The key to bridge is not mathematical skill.
 Instead, you must think logically.

17. When you are missing an odd number
 of cards, expect them to divide
 as evenly as possible.

17. On the other hand, when you're missing
 an even number of cards, don't expect them
 to divide perfectly.

Chapter 2 - Count Your Way to the Top

Chapter 3 - Finesses: Not Always Obvious

Chapter 4 - To Finesse or Not to Finesse

Chapter 5 - YOU *Can* Execute an Endplay

Chapter 6 - Tricks of the Trade

Chapter 7 - Life in Notrump

Page #

75. Regarding the Rule of 11:

 - After a fourth-best lead, declarer can subtract the value of the card led from 11 and know how many cards above the card led are held by his RHO.

 - It does not apply when an honor card is led.

 - It applies on any 4th-best lead, not just the opening lead.

 - It *does* apply in suit contracts, as long as the defender has led fourth-best.

 - High spot cards yield more specifics about declarer's RHO's cards than lower cards.

76. In a notrump contract, declarer's first thought should be to apply the Rule of 11 (except when an honor was lead).

79. Hands with a blocked suit are often more difficult to play than they appear to be.

80. On most hands containing a blocked suit, you need to unblock the suit ASAP.

82. Declarer must be careful to prevent the dangerous opponent from obtaining the lead.

Chapter 8 - Entry Problems in Notrump

Chapter 9 - Drawing Trumps

Chapter 10 - Timing Is Everything

Chapter 11 - Count Winners in Suit Contracts

Chapter 12 - Pesky Partscores

Chapter 13 - Setting Up Your Long Suit

Chapter 14 - Making the Most of Your Entries

Chapter 15 - Don't Rely on Good Splits

Chapter 16 - Squeezing is Pleasing

Bidding Highlights

Bidding Highlights...continued

Defensive Highlights

Defensive Highlights...continued

Declarer's
Glossary Plus

Avoidance Play – A declarer-play technique designed to prevent the "dangerous defender" from obtaining the lead.

Bath Coup – After LHO leads the king, declarer's hold-up play from 3+ cards including the AJ. He is hoping that the defender will continue the suit so he can win a cheap trick with his jack.

Blocked Suit – A suit in which it is impossible to immediately cash all the winning cards. For example, AQ opposite Kxx.

Blocking a Suit – A play which results in a blocked suit. Blocking the opponents' suit is highly recommended; blocking your own suit is not.

Board – Dummy's hand. *On the board* means that the previous trick was won by the dummy's hand.

Break a Suit – Slang for leading a suit.

Capture – Playing a high card to take away a trick from an opponent.

Card Reading – Drawing inferences about the opponents' hands based on the cards that were already played.

Card Sense – Having a special aptitude for playing card games.

Cash – To lead a winning card and take the trick.

Claim – Declarer shows his cards and announces his intention to win or concede a certain number of tricks. He also must *carefully* state his exact line of play. Warning: only make a claim when 1000% sure. An imperfect claim can cause "all hell to break loose."

Cold (Laydown) – A slang term describing a contract that is easy to make.

Communication – The ability to win tricks in either declarer's or dummy's hand. If the partnership assets are not evenly divided, limited communication can result in entry problems.

Concede – To give up one or more tricks to the opponents, usually near the end of the deal.

Counting – One of the abilities that separates BRIDGE PLAYERS from bridge players. Good declarers count: trumps, distribution, HCP, tricks, etc.

Count Losers in a Suit Contract – On most hands, this is the recommended approach. However, always feel free to count winners when you think that doing so will be more helpful to *you* on the deal in question. I count winners on crossruffs, partscores and slams.

Count Trumps – I suggest focusing on the trumps in the defenders' hands.

Count Winners in Notrump – Yes, you should, although you must also be aware of the number of tricks the defenders can win.

Crashing Honors – A play by declarer resulting in the defenders' wasting two honors on the same trick.

Crossruff – A method of play where declarer is able to ruff in both his hand and the dummy's. On a crossruff hand, declarer should cash his side-suit winners ASAP, and not lead trumps.

Danger Hand – See *avoidance play.* The defender who can jeopardize the contract if he gains the lead.

Deceptive Play – Any play that is made in the hope of deceiving your opponent(s).

Deep Finesse – A finesse that involves a card below the jack.

Develop (Establish) (Set Up) – To promote a card (or cards) into winners by forcing out the opponents' higher card(s) in that suit.

Discard – Throwing off a card in some other suit (but not trumps) when you are void in the suit led.

Discovery Play – A play made to learn more about the defenders' hands.

Double Dummy – A hand that was played perfectly, as if the player was looking at all four hands.

Draw Trumps (Pull Trumps) – Lead trumps to remove them from the opponents' hands. Too many players draw trumps too often and too soon.

Drive Out – Forcing an opponent to take a trick with his winning card in order to set up tricks for your side.

Duck – Playing a small card to surrender a trick you could have won now, but would prefer to win later. Most players do not duck often enough.

Dummy Reversal – Creating an additional trump winner by intentionally ruffing with the partnership's longer trump holding. This *reverses* declarer's normal thinking, where he prefers to ruff in the hand which has fewer trumps.

"Eight Ever, Nine Never"– A guideline for deciding whether to finesse when missing the queen.
In general, with a combined holding of eight cards, you should finesse; but with nine, play for the drop.

Eliminate (Strip) – Removing safe exit cards from the opponents' hands to set up an endplay.

Endplay (Throw-In Play) – Based on "last is best." You need to throw in a defender with a sure loser to allow you to win an extra trick in your "iffy" suit. Your opponent will be forced to solve your problem, or give you a ruff and sluff.

Entry – Any card that allows you to gain the lead to a particular hand.

Establish – See *develop*.

Exit – To intentionally give the lead to the opponents.

Finesse – A maneuver to try to win a trick with a card that is not yet a winner. You hope that the defender's honor is located in front of your relevant card. Too many players are too eager to take finesses.

Good Guy, Bad Guy – See *avoidance plays and danger hand.* Refers to deals where one defender is dangerous, while his partner can't hurt you.

Grab – Too many players are anxious to win tricks as soon as they can, without considering the big picture. Good players don't grab; they develop.

Hold-Up Play – Refusing to immediately win a trick in the hopes of cutting the opponents' communication.

Iffy Suit – A Bergenism denoting a problem suit, in which you'll benefit greatly if a defender leads it. One example is: Qxx opposite Jxx.

Incomplete Trump Removal – Drawing most of the defenders' trumps, but leaving them with a high trump (or two).

Inference – A conclusion drawn from a call or play made by one of the other three players.

Intermediates – Tens and nines (and even eights). Good players appreciate these cards, while other players often do not.

Intra-Finesse – A suit combination where declarer intentionally takes a losing deep finesse against one defender, but then follows with a winning finesse against the other defender.

"Last is Best" – A Bergenism that emphasizes the huge advantage enjoyed by the player who plays fourth when a suit is led.

Laydown – See *cold*.

LHO – Your left-hand opponent.

Lose Control – When declarer can no longer make his contract because the defenders are able to win tricks in their long suit. In suit contracts, often the result of declarer's running out of trumps.

Loser on Loser Play – Instead of trumping the defender's winning card, declarer discards an inevitable loser. This technique is only recommended when based on a logical reason.

"Lose Your Losers Early" – Excellent general advice intended to remind declarer to "develop, not grab."

Maintain Control – The opposite of *lose control.*

Marked Card – A card that is known from a previous play to be in the hand of a particular defender.

Marked Finesse – A finesse that is expected to win, based on the bidding or early play.

Master Hand – The hand in which declarer will develop the tricks he needs. This is usually declarer's hand based on his trump length.

Menace (Threat Card) – A card, in declarer's hand or dummy's, that forces a defender to keep a higher card in the same suit to prevent it from becoming a winner.

Mirror Distribution – A deal where both declarer and dummy have the identical length in all four suits.

Negative Inference – A deduction made from a player's failure to take an alternative action in the bidding or play.

Overruff – Overtrumping an opponent.

Overtake – The play of a higher card than the one partner played in order to unblock or to win the trick in your own hand.

Percentage Play – Declarer's best chance.

Pitch – Slang for discard.

Proven Finesse – A finesse that is sure to win.

Pseudo-Squeeze – The defender is not squeezed, but helps declarer by discarding incorrectly.

Rabbi's Rule – "When the king is singleton, play the ace." More whimsical than serious advice.

Rectifying the Count – Losing one or more tricks early in order to put maximum pressure on the defenders in preparation for a squeeze.

Restricted Choice – An advanced guideline that can help declarer "locate" missing honor cards. When a defender follows suit with an honor, any adjacent cards are more likely to be located in the hand of the other defender. This is especially useful when declarer is working on his long suit.

RHO – Your right-hand opponent.

Ruff and Sluff – When a defender leads a suit in which both declarer and dummy are void, declarer can trump (ruff) in one hand and discard (sluff) a loser from the other. As long as declarer has trumps in each hand, a ruff-sluff will almost always prove to be beneficial for his side.

Ruffing Finesse – A method for declarer to develop trick(s) from a sequence opposite a void. Declarer leads an honor and discards a loser if the honor is not covered. Even if the finesse loses, he expects to set up at least one of his remaining cards in that suit.

Rule of 11 – This does apply in suit contracts, but it is more relevant in notrump. After a 4th-best lead, subtract the value of the card led from 11. This total represents the number of higher cards held by the other three players (excluding the opening leader).

Run – Cash all the winners in an established suit.

Safety Play – A play that ignores the possibility of overtricks, while giving declarer the best chance to make his contract. Since overtricks are so important in matchpoint duplicate, safety plays are more relevant when playing rubber bridge or in a team game.

Scissors Coup – A loser-on-loser play to prevent the dangerous opponent from obtaining the lead.

Score Up – Slang for making your contract.

Scramble – Ruffing without attempting to retain control of trumps.

"Second Hand Low" – The play of a small card when your RHO leads a suit, because your partner still has a chance to compete for the trick. Recommended in general, but there are many, many exceptions.

Set Up – See *develop*.

Short Hand (Short Side) – The hand of the partnership that has fewer cards in the suit in question.

Show Out – Fail to follow suit.

Side Suit – Any suit other than trumps.

Split – The way in which a suit is distributed in the opponents' hands. All players hate to get bad splits in their key suits.

Spot Cards – Any card from two through nine.

Squeeze – A series of plays that forces one or both defenders to throw away a card that costs a trick. This tactic represents declarer's best hope when he seems to have "no chance" to avoid a loser.

Stopper – A card or combination of cards that prevent the opponents from running a suit in notrump.

Strip – See *eliminate.*

Suit Combination – A partnership's combined holding in one suit. Declarer tries to use good technique in developing that suit, such as "eight ever, nine never."

Tenace – A non-sequential holding of honor cards. The two most common examples are AQ and KJ.

"Third Hand High" – The play of a high card to try to win the trick or prevent your LHO from winning a trick cheaply. Used when competing for the trick in a suit that partner led. Good general advice, but there are many exceptions.

Throw-In Card – See *endplay.* An inevitable loser that is led to force a defender to solve declarer's problem in another suit.

Timing – The order in which trumps are drawn, losers are trumped, and side suits are developed. All declarers strive to achieve "good timing."

Transportation – The ability to transfer the lead from one partnership hand to the other.

Trump Coup – Trapping your RHO's trumps when you are unable to finesse. On some deals, declarer needs to reduce his number of trumps so that he has the same number as his RHO.

Two-Way Finesse – A position in which declarer needs to guess which opponent holds a missing honor so he can finesse through that player. One example is Q 9 x opposite K 10 x, where declarer wants to avoid losing a trick to a defender's jack.

Unblock – To play or discard a high card that prevents your side from winning all the tricks you are entitled to in a particular suit.

Unmakable – A contract that cannot succeed unless the defense errs.

"Use Up the Honor(s) From the Short Side First" – Excellent general advice to avoid blocking the suit that you, as declarer, are leading. It does not necessarily apply when the defenders break the suit.

Where to Trump? – In general, declarer is eager to trump in the hand with fewer trumps.

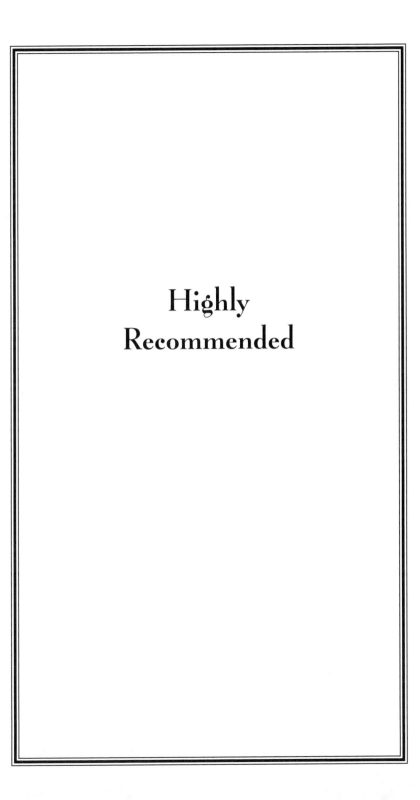

Highly
Recommended

Hardcover Books by Marty Bergen

More Declarer Play the Bergen Way $18.95
How to Make More Contracts

Declarer Play the Bergen Way $18.95
2005 Bridge Book of the year!

Bergen for the Defense $18.95
Sharpen Your Defensive Skills

MARTY SEZ... Volume 1 $17.95
Bergen's Bevy of Bridge Secrets

MARTY SEZ... Volume 2 $17.95
More Secrets of Winning Bridge

MARTY SEZ... Volume 3 $17.95
Practical Tips You Can Take to the Bank

POINTS SCHMOINTS! $19.95
Alltime Bestseller and Bridge Book of the Year

More POINTS SCHMOINTS! $19.95
Sequel to the Award-Winning Bestseller

Schlemiel...Schlimazel? Mensch! *(nonbridge)* $14.95
An Entertaining Guide to Becoming the Best You can be

•• VERY SPECIAL OFFER ••

Buy one of these hardcover books from Marty
and receive a **free** copy of any one
of his eight most recent softcover books.
Buy 2 hardcovers and get 3 free softcover books!
Personalized autographs available upon request.

Softcover Books by Marty Bergen
Buy 2, then get 1 (equal or lesser price) for half price

Bergen's Best Bridge Tips	$7.95
Bergen's Best Bridge Quizzes, Vol. 1	$7.95
To Open or Not to Open	$6.95
Better Rebidding with Bergen	$7.95
Understanding 1NT Forcing	$5.95
Hand Evaluation: Points, Schmoints!	$7.95
Introduction to Negative Doubles	$6.95
Negative Doubles	$9.95
Better Bidding With Bergen –	
Volume 1: Uncontested Auctions	$11.95
Volume 2: Competitive Bidding	$11.95

Books by Eddie Kantar

A Treasury of Bridge Bidding Tips	$12.95
Take Your Tricks (Declarer Play)	$12.95
Defensive Tips for Bad Card Holders	$12.95

The Official Encyclopedia of Bridge
(more than 800 pages)

Highlights include extensive sections on:
suit combinations, explanation of all conventions,
techniques for bidding, defense, leads, declarer play,
and a complete glossary of bridge terms.

**The encyclopedia retails for $39.95
Marty's price: $23 + shipping,
which inludes a free softcover book (choice of 8)**

♠ ♡ **Bridge Cruises** ◇ ♣
with Marty Bergen and Larry Cohen

For prices, itinerary, flyers etc or to be on the mailing list for
Marty and Larry cruises, call Bruce Travel at 1-800-367-9980.
To participate in bridge activities, you must book the cruise
with Bruce Travel. These cruises feature daily lessons,
as much duplicate bridge as you care to play (including ACBL
masterpoints), plus all the activities, entertainment and
ambiance that you'd expect to find on a first-class cruise ship.

Upcoming Caribbean Cruises with Larry and Marty
Both depart from Ft. Lauderdale, Florida

21- time National Champion, Larry Cohen's.2007 cruise
will take place **Sunday Nov 3 thru Nov 10.**
You'll be delighted with Larry's very unique presentation.

Popular author/lecturer/teacher/ Marty Bergen, author of 19
books and 10-time National Champion, will host his next cruise
Sunday Nov 16 thru Nov 23, 2008. Highlights include:
Daily lessons with brand-new material and a dynamic approach;
****Free private lesson for groups of 5+ who sign up together;**
Free Bergen book for all who sign up early.;
*****Free drawing to play duplicate on cruise with Marty.*****

Interactive CDs by Marty Bergen

POINTS SCHMOINTS!	~~$29.95~~	$25
Marty Sez...	~~$24.95~~	$20

Very Special Offer! Get both CDs for $30
For free demos of Bergen CDs, e-mail Marty at:
mbergen@mindspring.com

Interactive CDs by Larry Cohen

Free demos available at:
http://www.larryco.com/index.html

Play Bridge With Larry Cohen

An exciting opportunity to play question-and-answer with a 21-time national champion. "One of the best products to come along in years. Easy-to-use. Suitable for all players..."

Special Sale!!

Day 1	voted best software 2002	~~$29.95~~	$19
Day 2		~~$29.95~~	$19
Day 3		~~$29.95~~	$19
My Favorite 52	best software 2005	~~$29.95~~	$19

CDs by Kit Woolsey

Cavendish 2000:

Day 1	~~$29.95~~	$19
Days 2-3	~~$29.95~~	$19

Software By Fred Gitelman

"Best software ever created for improving your declarer play."

Bridge Master 2000	~~$59.95~~	$48

**Mention this book and receive a free Bergen softcover (choice of 8) with each Gitelman CD.

Books by Larry Cohen

To Bid or Not to Bid - The Law of Total Tricks	$12.95
Following the Law - The Total Tricks Sequel	$12.95
Bidding Challenge	*$15.95*

One-on-One with Marty

Why not improve your bridge game with an experienced, knowledgeable teacher?
Enjoy a private lesson with Marty Bergen.
You choose the format and topics.
Q&A, conventions, bidding, cardplay etc.

Marty is available for lessons via phone and by e-mail. Beginners, intermediates, and advanced players will all benefit from his clear and helpful teaching style.

For further information,
call the number below, or e-mail Marty at:
mbergen@mindspring.com

ORDERING INFORMATION

To place your order, call Marty toll-free at:
1-800-386-7432
All major credit cards are welcome

Or send a check or money order (U.S. funds), to:

Marty Bergen
9 River Chase Terrace
Palm Beach Gardens, FL 33418-6817

If ordering by mail, please call or email for S&H details